GUSTAVE DORÉ
A Biography

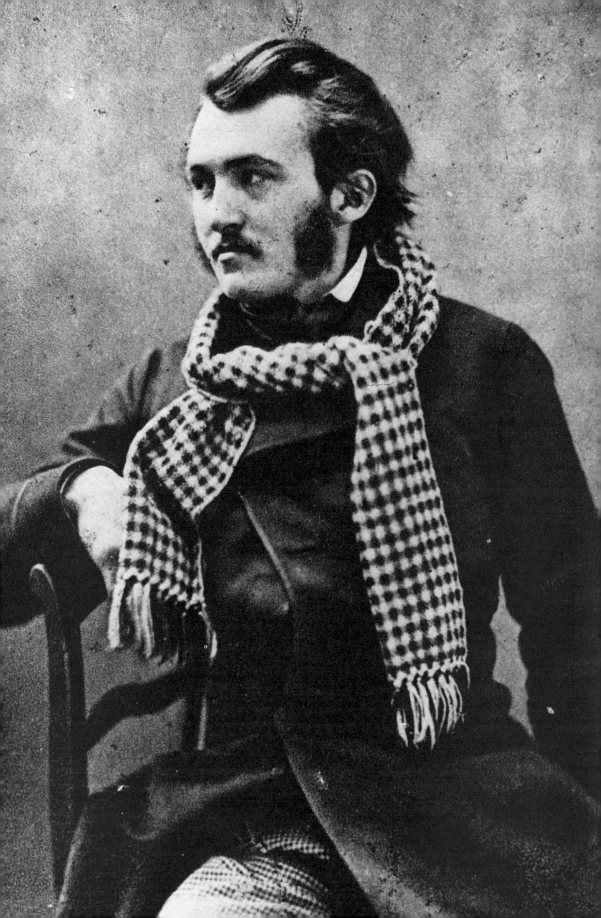

Joanna Richardson

GUSTAVE DORÉ
A Biography

Cassell
London

CASSELL LTD.
35 Red Lion Square, London WC1R 4SG
and at Sydney, Auckland, Toronto, Johannesburg,
an affiliate of
Macmillan Publishing Co., Inc.,
New York.

First published 1980

ISBN 0 304 30455 7

Picture acknowledgements

The pictures on the respective pages of this book are
reproduced by courtesy of the following:
The British Library – 47 (top); 52; 155.
Cambridge University Library – 17; 25; 34; 40; 42; 44; 45;
47 (bottom); 50; 53; 59; 60; 80; 81; 84; 86; 94; 104; 107;
108; 113; 114; 116; 121; 128.
Cassell Archives – 6/7; 10; 21; 31; 32; 36; 39; 54; 62; 67;
70; 75; 83; 111; 122; 125; 134; 142; 148.
The Mansell Collection – frontispiece; 14; 22; 89; 97; 98; 102.
The Mary Evans Picture Collection – 100; 101.
The Radio Times Hulton Picture Library – 28; 48; 139.

Frontispiece
Gustave Doré. From a photograph by Nadar, c. 1855

Pages 6 and 7
The artist reclining. Gustave Doré in middle age.
From a photograph by O. G. Rejlander, c. 1870

Photoset by Rowland Phototypesetting Ltd.
Bury St. Edmunds, Suffolk.
Printed and bound in Great Britain by
William Clowes (Beccles) Limited, Beccles and London

Contents

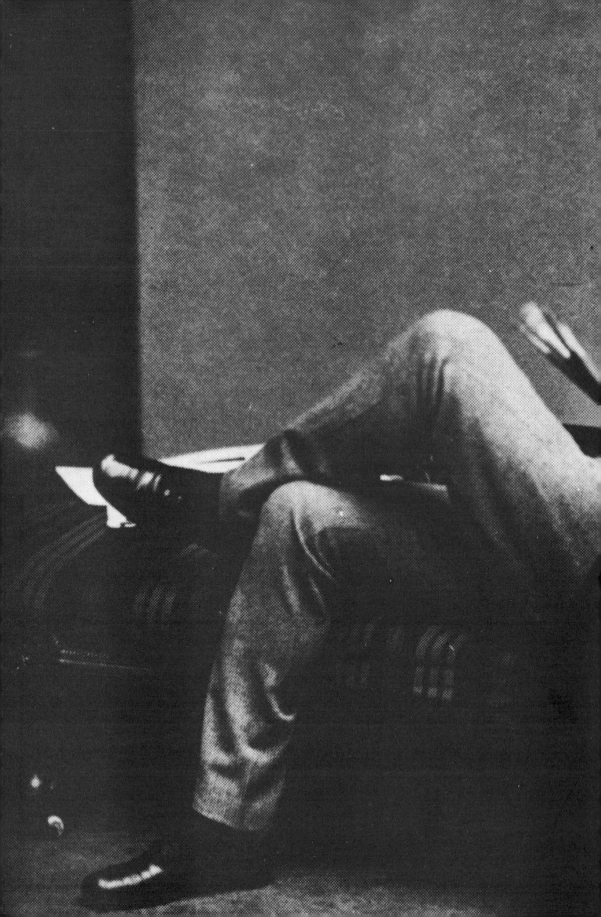

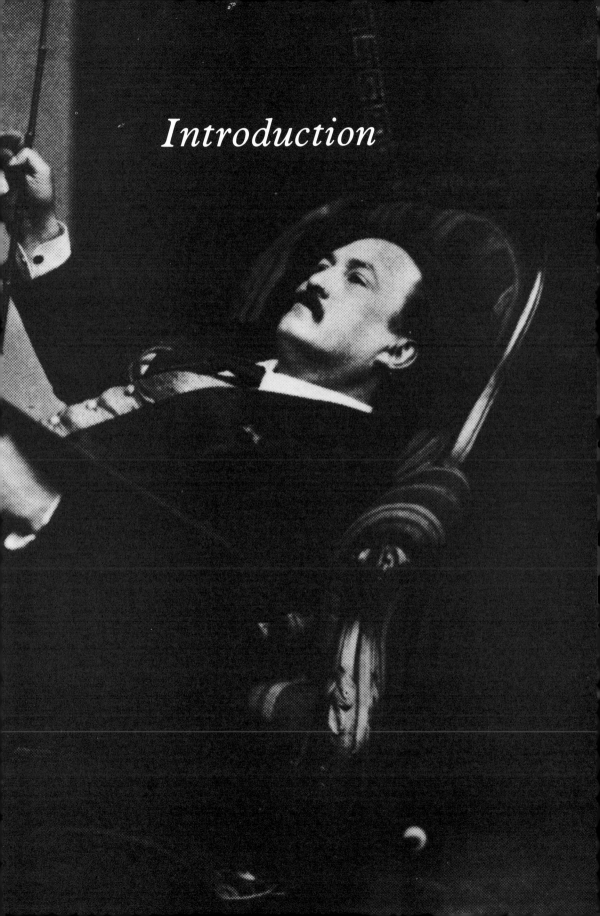

Introduction

'He was born a poet. He was a painter, and he died a sculptor. On the way he had peopled the masterpieces of world literature with memorable pictures.' So wrote one of Gustave Doré's biographers, and it is a fair summary of his career. From his earliest childhood, Doré was rarely without a pencil in his hand; he drew with a compulsion, an energy and brilliance which astonished his contemporaries and astounds us still to-day. He had no time for the academic study of drawing or painting. He was almost entirely self-taught. He trained his remarkable visual memory, he allowed his imagination full rein; and, from the age of four until his death at fifty-one, he devoted himself to his art. 'When Doré died, still young,' observed Jules Claretie, 'people suddenly realised the creative powers of an artist whom they were ready to relegate, in his lifetime, among the journalists of the pencil . . . Doré had committed the crime of fecundity. It appears that this is unforgivable.'

Doré had undoubtedly been 'a journalist of the pencil'; he had illustrated popular, topical themes. As a youth of twenty-two, he had also established his pre-eminence as an illustrator of books. Like the critic in *The Athenæum*, we are well aware that 'at one moment Doré designed like a wizard of incomparable power, at another time like a mountebank'. Perhaps he suffered from his lack of artistic education, perhaps he suffered from a lack of human experience. No doubt he drew too fast and too much. But the wizardry remains; and we only regret that he did not live to use all his powers.

Like other men, he misunderstood the nature of his gifts. He was not the painter of genius he thought himself to be. His vast religious pictures, his immense battle-scenes, his topical and melodramatic canvases: all these detracted from his reputation. But his monument to Dumas *père* suggests his powers as a sculptor; his illustrations and his paintings remind us, repeatedly, that he would have been a superb scene-designer. 'What artist seems better fitted than he does to be the great decorator of this century?' So René Delorme asked in 1878. 'Doré is, above all, a decorator, he is called to paint a new Last Judgment on the walls of a new Sistine Chapel . . . I trust that they do not wait for Gustave Doré to be dead before they discover

his church.' Doré decorated no chapel or palace or theatre. He died, his dreams unrealised, believing that he had not received the recognition that he deserved, and that he had not used all his gifts.

By his intense and unremitting activity, by his greatness and his occasional mediocrity, Doré is a figure of the Second Empire. He belongs to an age of meteoric careers, an age of constant pressures, an epoch when men made sudden fortunes and created fashions, and Parisians were bent on the quest for pleasure. Doré belonged to *le tout Paris*. He was a famous member of the brilliant, rich, none too scrupulous society who enjoyed the favours of Cora Pearl, delighted in Offenbach, and understood little about the poor, and nothing of the true state of France. In his work, he tried to escape the reality of Second Empire France. He even attempted to become a Victorian religious painter. But he belongs to the Second Empire inescapably. As Blanchard Jerrold recognised: 'The value of his work apart, he is a remarkable figure of his time.'

He is a sad figure, too; for one cannot avoid the conclusion that his mother destroyed him by her exclusive, overwhelming love, and by her refusal ever to free him. Doré spoke in later life of 'the duties which overburden me'. Perhaps he did not only mean his professional obligations. There were surely times when he wanted independence. For all its brilliance and achievement, his life was melancholy. I have tried to present it as a study of human relationships, as a period piece, and, above all, as an account of *'un gamin de génie'*.

I should like to express my gratitude to the Principal and Fellows of Somerville College, Oxford, for their hospitality, and for their permission to use Doré's letters to Amelia Edwards. I am much indebted to Mr Sam Clapp, for his generous help and advice. I am grateful to the Librarian, Warwick Castle, to Mr Norman Lambert (Company Archivist, Cassell Ltd), to Messrs Sotheby Parke Bernet, and to Messrs Justin G. Schiller Ltd. I must, as usual, record my thanks to the patient staff of the British Library.

June 1978 **Joanna Richardson**

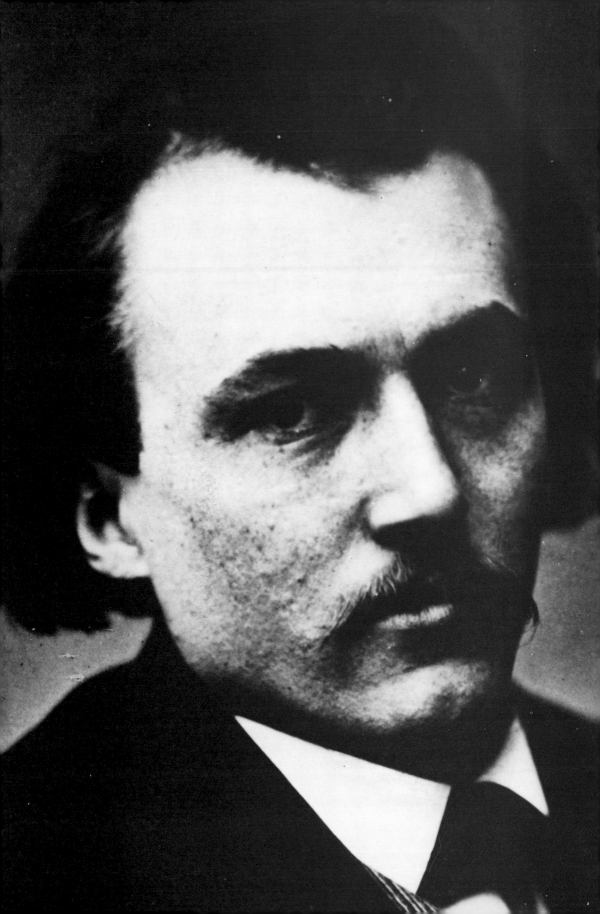

I

'Un gamin de génie'

1832–1855

Opposite
Gustave Doré. From a photograph by Nadar

11

I

Between the Black Forest and the Vosges mountains lies a valley crossed by the Rhine. From Basle to Lauterbourg the river is the frontier of France. Geologists believe that this valley was once the basin of a vast lake; and indeed the mountain slopes show traces of the ancient presence of the waters. On the summits one may still discover fossils of plants and shells which are foreign to this region of Europe. The part of the valley which lies on the left bank of the Rhine used to be the province of Alsace.

For a long time, now, Alsace has been divided into two *départements*: Haut-Rhin and Bas-Rhin. Yet, despite its French divisions, the old province has always been distinctly German in its character. The names of its towns and many of its inhabitants, the dialect spoken by the working class are German rather than French, and one at least of Gustave Doré's biographers has wondered whether his 'touch of German wildness' could be attributed to his birthplace. Wildness, fantasy, cruelty and persistent sentimentality: perhaps he owed them all to Alsace. Blanchard Jerrold, who knew him well, once called him 'the most German of French painters'.[1]

The Dorers (for the name had once had a German spelling) were an Alsatian family. Doré's grandfather had been an officer in Napoleon's army, and he had been killed at Waterloo. Doré's father, Pierre-Louis-Christophe Doré, had been brought up by his widowed mother. He had attended the École polytechnique in Strasbourg and become a civil engineer. By 1829 he was an engineer (second class) in the Département des Ponts et Chaussées; that year, at the age of twenty-seven, he married Alexandrine-Marie-Anne Pluchart. Her family, also Alsatian, were prosperous bourgeois from Schirmeck in the Vosges; and her mother, it is said, was known for her beauty. Alexandrine herself was dark, with large oriental eyes; she was in turn capricious and decisive. She had a hasty temper, and she did not always try to control it. But she and her husband were happy; they already had a son, Ernest, when, at six o'clock in the morning of 6 January 1832, Alexandrine gave birth to Louis-Auguste-Gustave: the son who was to be, and remain, '*un gamin de génie*'.

Doré entered the world at 5 (now 16), rue de la Nuée-Bleue, in Strasbourg. He might have designed the setting for himself and, indeed, it was to have a lasting influence upon him. The house stood in one of the picturesque streets which gave on to the cathedral. The great church itself dominated Strasbourg. Built between the thirteenth and fifteenth centuries, it showed every style of Gothic architecture, and it was adorned with rich and varied sculpture. As soon as Doré grew aware of the world about him, he became aware of the huge, soaring edifice; it gave him a feeling for the Gothic, for immense height and distance, which was to be reflected in his work. In 1834 the family moved to 6, rue des Écrivains; the new house had a spiral staircase dating from the Renaissance, a romantic feature which was to haunt Doré all his life.

As he grew older, he explored the ancient, romantic city. The gabled houses were built of stone, with two and three tiers of dormer windows in their high tiled roofs, and there were sometimes storks' nests on the chimneys. The fortifications had been designed by Vauban himself. No doubt Doré's father took him to the Musée d'Histoire Naturelle, and to the Jardin Botanique, which had been established in the distant reign of Louis XIII. One suspects that Monsieur Doré also showed him the place Kléber, and pointed out the statue of the general, born in Strasbourg, who had taken Alexandria by assault and died at the hands of a mameluke at the turn of the century.

As a small boy, Jerrold tells us, Doré would rise at dawn and watch the light steal across the spires of Strasbourg.[2] The old city stood on an island between the rivers Aar and Ill, and beyond the walls lay a landscape rich in romantic beauty. The rugged mountains of the Vosges were thickly wooded, and broke out here and there 'into precipitous rocks of sandstone, limestone and marl. The valleys lying among the folds of these mountains are distinguished for their pastoral loveliness,' wrote Edmund Ollier, in his memoir of Doré. 'On the peaks that surround them the snow lies unmelted until the middle of the summer, feeding the numerous streams which course down the sides of the Vosges, and ultimately find their way into the Rhine. The valley of the Rhine is a large tract of country of great interest and beauty; and all about lie famous old battlefields.'[3]

13

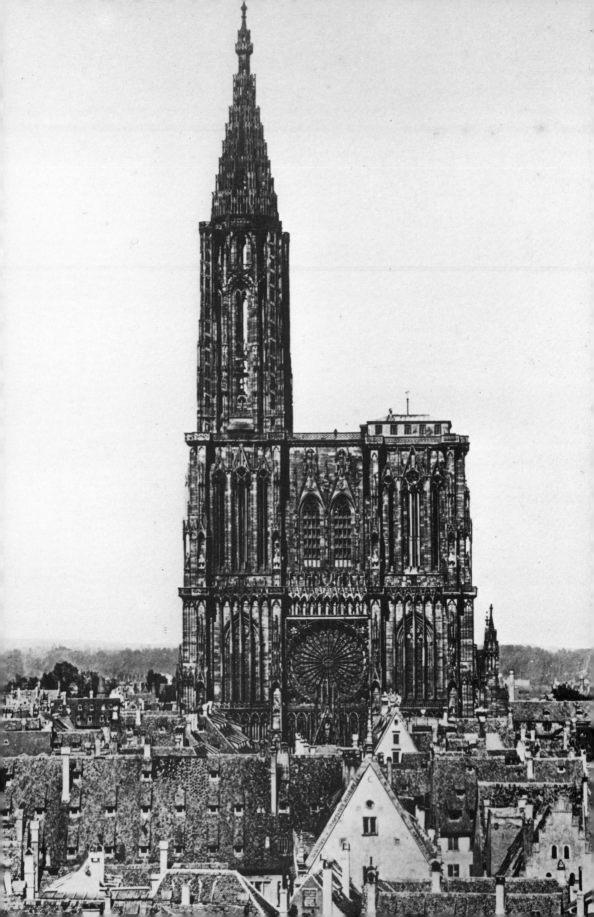

An anonymous guide to Strasbourg, published in 1858, recorded the fecundity of the local soil. Through this luxuriant countryside, every Wednesday and Friday, the peasants used to make their way to the Strasbourg market. As dawn broke, one would see them bringing in their abundant produce. The men wore black ratteen coats and scarlet waistcoats with metal buttons. The women wore skirts of red or green serge, edged with ribbons of different colours. On their bodices were triangular plaques covered with gold and silver cloth. They wore little bonnets of the same fabric.[4]

The Alsatians, noted the same guide, were 'robust and well constituted'. They were slow to make decisions, but, 'once they have decided, they pursue their aim with an energy and perseverance which nothing can stop'.[5] Gustave Doré was endowed with an Alsatian constitution, and with Alsatian determination.

<p style="text-align:center">★ ★ ★</p>

In the first years of his life, Doré was steeped in Strasbourg history and legend. He was always to abide in spirit with saints and gnomes and elves, and to live more in the ideal world than in reality. He was always to believe in illusions and to expect a miracle to happen as soon as he set his heart on anything. In the first years of his life, he lived between the towering cathedral and the looming pinewoods. 'These spectacles,' he was to write, 'were my first vivid impressions. They were those *éblouissements d'enfant* which determine a taste.'[6] For the remainder of his days he was to love dark woods, deep narrow valleys and streams: the kind of countryside which he explored on Sundays, with his father and two brothers. His last excursions from Paris were to be to the Righi Vaudois and the Pyrenees.

Almost from the beginning, irresistibly, he recorded the romantic world around him. After his fourth year, he was never found without a pencil. Sometimes, when he could not sleep, he would crawl out of his cot and into his mother's room, and cry: 'Maman, I don't know what's the matter. I want to draw.' He would go back to bed, content, with a pencil in his hand. Such

Strasbourg Cathedral. Doré was born in its shadow, and spent his early childhood within sight of its soaring tower

was his compulsion to draw that his pencil was always sharpened at both ends.[7] From the age of five, he illustrated his exercise-books and letters. He drew the old women in the market, his family and friends, the exploits of Abd-el-Kader (who was fighting the French in North Africa), and the classical stories which his teachers taught him. He made a little book for a neighbour and family friend, Mme Braun, describing the adventures of her dog: *Les Brillantes Aventures de M. Fouilloux.* Before he was six he wrote a letter to his schoolfriend Arthur Kratz and drew a sketch of himself as an ant, carrying off the first prize at school. He was fascinated by the satires of Jean Gérard, better known as Grandville, who caricatured human life in terms of animals. Edmund Ollier records that 'young Doré produced some sketches of the same description, and Grandville, to whom they were shown, was so delighted that he prophesied the future greatness of the boy, and strongly advised the parents not to oppose his natural inclinations. Grandville also encouraged his tentative efforts by sympathy and kindness.'[8]

The brilliantly precocious child also found time to indulge in escapades. One evening, when he was seven, and staying at Barr, in the Vosges, he ran off into the hills, and climbed to the shrine of Odile, the local saint. He fell asleep in the woods and woke at midnight, terrified. The creaking, sighing trees made him think that wolves were after him. His father, with a search party, had set out to find him; they met him as he ran wildly home.

As a boy, recorded Blanchard Jerrold,

he built a *montgolfière,* or fire-balloon – it fell in a barn full of hay, which it fired, and caused a dangerous conflagration. His father's scolding so impressed him that he could never after look without aversion at a balloon. He was a great kite-flyer also . . . But it was as a gymnast that Gustave at play was most remarkable . . . His daring at rope-climbing, . . . at wrestling and swimming, and even as a rider, was remarkable . . . He was fond of walking through marshy districts on stilts, in the fashion of the Landes . . . He was a good skater, and an intrepid swimmer.[9]

Classroom scene. An inspired sketch by the young Doré

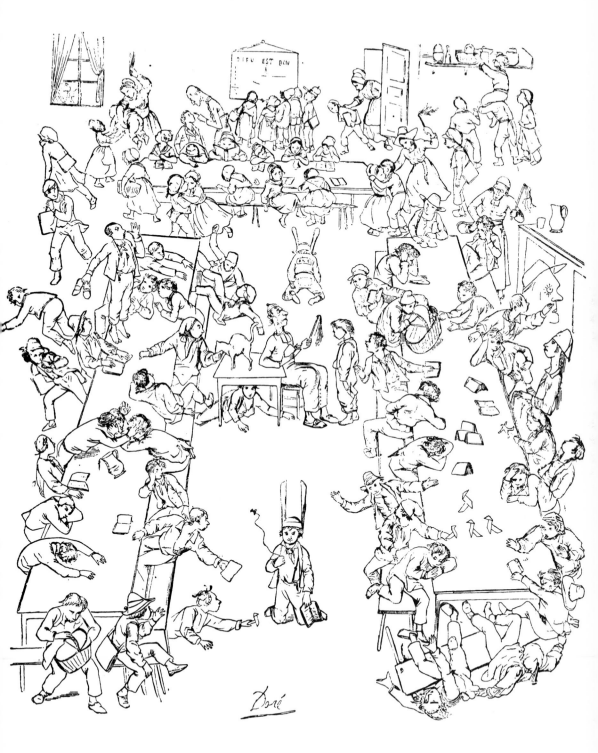

Gustave's elder brother, Ernest, had a talent for music; his younger brother, Émile, was less artistic, but intelligent (he was one day to reach high rank in the army). But Gustave was – perhaps too plainly – the favourite of the three. He was small for his age, fair-haired and pretty. He was adored by his mother and his nurse. They admired his talent for drawing, his gift for the violin. They marvelled when, at seven years old, he played the whole of *Robert le Diable.* He had had no music lessons, but he picked up tunes and played them by ear. He was fond of acting, too, and revelled in dressing up.

But, for all his versatility, his course was already plain. At the age of six he announced that he intended to be an artist.

On 13 November 1840 Strasbourg held a fête in honour of John Gutenberg. It was in Strasbourg, in the fifteenth century, that Gutenberg had made his first attempts at the art of printing which he invented. David d'Angers, the Romantic sculptor, now presented the city with a statue. It was inaugurated in the place Gutenberg; and in the procession which marked the occasion, fifteen decorated chariots represented the city companies. Soon afterwards Gustave suggested that he and his friends should celebrate their schoolmaster's birthday by re-enacting part of the procession. His visual memory was astonishing. He made copies of the banners from memory, he decorated carts and dressed up his friends. He made his own first appearance as an artist in the chariot of the Glass Stainers' Guild. On Professor Vergnette's birthday, the boys brought their procession into the place de la Cathédrale, where the École centrale stood. Gustave, in medieval dress, drew faces in the crowd, and tossed his sketches to the people round him.

<p style="text-align:center">★ ★ ★</p>

Soon afterwards, in 1841, Monsieur Doré was appointed chief engineer for the Département de l'Ain. He moved with his family to Bourg-en-Bresse. Gustave and Émile became half-boarders at the Pension Ollivier, which prepared its pupils for the Collège de Bourg. In October 1843 Gustave became a *collégien.* He entered the college preceded by his reputation as a draughtsman. His masters had the sense not to thwart his

vocation, and they let him draw in his exercise-books. Once, by way of translation, he submitted a drawing of the murder of Clitus. The master promptly gave him first place. In 1845 he was commended for his excellence; he also won the first prize for Latin composition and the second prize for Greek composition. The following year he won a prize for drawing. In 1847 – the year before he left – he was again commended for his excellence. During his free time he roamed the countryside, his drawing-block under his arm. He often went with his father into the Alpine foothills where Monsieur Doré was helping to build the railway line from Lyons to Geneva. Ernest Doré was to keep a portrait of his father which Gustave had painted in his youth.

It was in Bourg that Doré was given his first box of colours; he caught a white hen and painted it green. In Bourg he received his only instruction in the art of drawing, at Mlle Jeannot's Academy of Art. He refused to draw from the model, and spent his time sketching the young girls in his class. He was not indifferent to them: indeed he began a little album of drawings and stories for one of them. History does not relate why he finally decided to give it to a *collégien* instead. Doré also developed an interest in the processes of reproduction. His father got him a stone, and he made experiments in lithography.

<p style="text-align:center">★ ★ ★</p>

Early in 1847 the Paris firm of Aubert published Gustave Doré's first album of lithographs: *Les Travaux d'Hercule*. It reveals the influence of the engaging Swiss draughtsman, Rodolphe Töpffer. That September, during the closing months of the reign of Louis-Philippe, Doré first visited Paris. His parents intended to stay there for three weeks at most. Doré was determined to remain there. He saw at once that in Paris lay his future as an artist.

2

It was in the place de la Bourse that Doré saw a printshop kept by the caricaturist and journalist Charles Philipon. There were numerous caricatures in the window. Doré took some work to the shop, and asked to see the owner. Philipon was kind and acute. He looked at Doré's drawings. Then he asked to see his father, and urged him to let the boy become an artist.

On 17 April 1848, Monsieur Doré and Philipon signed a contract. Gustave was commissioned to produce a weekly cartoon for Philipon's new *Journal pour rire*. He was bound to work exclusively for Philipon for three years. He was also to attend the Lycée Charlemagne as a full-time pupil, and to pay for his school fees and his keep out of his earnings. At the age of sixteen, Doré began to earn his living.

At the Lycée Charlemagne, he met the brilliant, witty, and outrageous Edmond About, one day to write *La Grèce contemporaine*. For a long while he and About were inseparable. About was later to recall:

> we counted one artist, and only one, among us, but he was an artist worth a hundred. He was a little pink, chubby fellow, three or four years younger than his classmates, not very good at Latin, but astonishing at gymnastics and very gifted in music. He also drew sketches in the margins of his exercise-books: sketches of such curious taste and such amazing fantasy, that the publisher Philipon did not hesitate to collect them in an album. This young boy was one day . . . to fill the world with his name. He was Gustave Doré.[1]

The professors at the Lycée Charlemagne proved to be as indulgent to Doré as their predecessors at Bourg. When the history master, Monsieur Girard, had discussed a Roman emperor with his class, he usually asked Doré to draw a portrait of Nero, 'so that these gentlemen really understand what I've

Madame Doré (G. Doré's Mother) by the artist, 1879

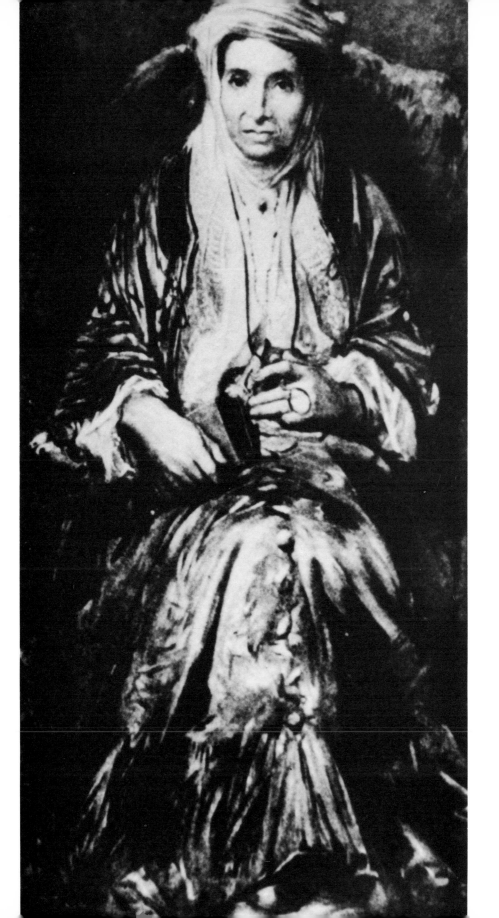

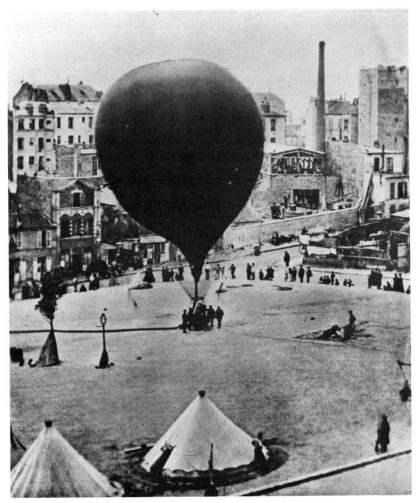

The Nadar balloon at Montmartre in which Gambetta escaped from Paris on 7 October 1870. From a photograph taken by Nadar

been saying'. Monsieur Berger, immensely fat, taught young Doré Greek. Like his forerunner at Bourg, he let him translate by drawing, rather than by words. He also added, prudently: 'As long as I take my class, there will never be any mention of Vitellius, because you would draw my portrait, and I still have a little pride.'[2]

In his moments of leisure, Doré studied the marbles at the

Louvre, the prints and drawings at the Bibliothèque Nationale. He observed life in the streets of Paris. Philipon introduced him to Félix Tournachon, better known as Nadar. The Bohemian cartoonist was one day to be an aeronaut, and to become the supreme French photographer of the century. Doré, he said, 'is an urchin who somersaults like a monkey and draws like an angel'. Doré was also encouraged by an old friend of the family: Paul Lacroix, the man of letters better known as le Bibliophile Jacob.

His first year in Paris was one of Revolution. By his upbringing, and by conviction, he was conservative and anti-republican, and for him the insurrections of 1848 were just another Gutenberg fête. He watched the fighting in the streets as an artist who was eager for experience. He said later that the scenes in the faubourg Saint-Antoine had helped him to manage crowds in his pictures.

During his early months in Paris, he boarded with Mme Hérouville, an old friend of his mother's, in the rue Saint-Paul, near the Lycée Charlemagne. Mme Doré, doting as ever, still came to Paris for weeks at a time to be near him. During the year 1848 they went to Dieppe; it was there that Doré painted *Un Pêcheur amarre sa barque avant la tempête*. He showed his picture to Paul Lacroix, who told him bluntly: 'Your drawing is good, but your painting is worthless.' It was Doré's first disappointment as a painter.

While his wife and son were away, Monsieur Doré was left in solitude at Bourg. On 24 April 1849 he asked, not surprisingly, to be transferred to Auxerre, or preferably to Paris. Fate determined his future for him. A few days later, on 4 May, he died of pleurisy. He was not yet fifty.

* * *

Ernest Doré was now nineteen, and an unqualified student of engineering. Émile was fourteen, and still at school. Gustave was already earning, but he was too young to be the chief support of his family. Their sole income, apart from his earnings, was 1,000 francs a year from Mme Doré's property.

Their financial situation was soon made easier. Mme Doré inherited a house in Paris: 73, rue Saint-Dominique, faubourg Saint-Germain. The house was said to have been built by the Duc de Saint-Simon.

In 1850 Doré left the Lycée Charlemagne. Lemercier de Neuville was later to explain: 'He was sure of arriving. He did not trouble to attest the validity of his studies by the diploma of *bachelier*.'[3]

During his years at the Lycée Charlemagne Doré had produced a large body of drawings. By 1853 it was calculated that he had done more than ten thousand. By 1870 the number was said to be more than twenty thousand. His invention was to be unceasing, his energy renowned; but his lack of academic training, his refusal to learn the technique of his art or to study human anatomy were to prove a permanent weakness. Admirers and critics alike were to recognise that he had not learned the fundamental rules, that he laboured under a permanent disadvantage.

There was another disadvantage which was much more serious. Emotionally, Doré never reached maturity.

* * *

More than one observer was to note his boyish appearance. Among them was the poet Théodore de Banville, who drew him in his *Camées parisiens*.

This pretty, rounded, childish face, with such pleasant, gay, intelligent small features, has a happy, simple expression. It is the sort that schoolboys give a good idea of by drawing a circle with three dots inside. If Gustave Doré looks so happy, it is because his imposition amuses him. And here is the history of this imposition. When he was a child, he scribbled drawings in the margins of all his schoolbooks. A wicked fairy condemned him to scribble drawings in the margins of all the books which have been written since the world began, and to remain a child until this was done. But the task will be completed soon. And then who will be caught? The wicked fairy.[4]

St Charlemagne – Toasting (*Two Hundred Sketches, Humorous and Grotesque*, 1867)

The wicked fairy was not caught; by keeping him a child, she had prevented him from enjoying manhood, enriching his art with experience of life.

Psychiatrists might well explain this immaturity by Doré's relationship with his mother. From the first, she made it plain that he was her favourite child. Her character was so strong, her love for him so exclusive and intense, that he found it increasingly difficult to form any other close relationship. At the age of nineteen, it is said, he fell desperately in love with the daughter of a Government official. He asked for her hand; her father refused him because of his small income and his uncertain future. The rejection stunned and hurt him; it strengthened the bonds between him and his mother. His life was not to be without love-affairs; but none of these was ever to wean him from her overwhelming affection. Until her death, he lived with her as if he were a child. He slept in a little room which led off her bedroom. He wanted her voice to be the first he heard every

morning, and the last voice which he heard at night. The communicating door was always open, and mother and son used to talk for hours before they went to sleep. Lacroix observed, later, that 'the profound love they bore one another filled up every other void in their lives . . . His adoration for her reached a point which made him indifferent to everything and everybody else.'⁵

His behaviour sometimes reflected this boyish streak in him. 'Doré was light-hearted, wild, a child,' wrote Gustave Claudin in his *Souvenirs*. 'When he was not working, he played the violin or abandoned himself to conjuring tricks.'⁶ He seems to have had a child's eagerness to attract attention. He remained an astonishing acrobat. Lemercier de Neuville records how, in the early 1850s, Doré and some friends went up one of the towers of Rouen Cathedral. While they were admiring the view of the Normandy landscape, Doré suddenly

> climbed over the balustrade of one of the towers, and began to gambol about among the architraves, the little columns and gargoyles; then, agile as a monkey, he seized the lightning conductor and, with infinite grace and terrifying aplomb, he performed the exercise which is known in gymnastics as a handstand . . .
>
> After several exercises, the daring young man climbed safely back on to the top of the tower.⁷

After this exploit, it is said, Doré was arrested by the police. They accused him 'of causing the utmost alarm to the inhabitants of Rouen.'⁸ But Doré was always to revel in dizzying heights. He was the first to climb the Aiguille de Floria, in Savoy, and he made many attempts to ascend the Matterhorn. Even in his latter days, he could still walk on his hands round the battlements of the castle at Baden, or the parapet of a top-floor apartment in Paris.

Doré was always to remain '*un gamin de génie*'. Gautier's phrase was to underline his strength and his weakness. The weakness was, alas, to be apparent in his art. Baudelaire later refused to have his work illustrated by Doré, 'because of the childishness which so often shows through his genius.'⁹

3

Years later, in the 1870s, the journalist Edmund Yates was to record a visit to 'the rue Saint-Dominique Saint-Germain, in the midst of the ministries, embassies, and sombre *hôtels* of the old aristocracy'.

> You pass [he wrote] under a great gateway, peculiar to the quarter, up a broad staircase to a spacious apartment, graced with French taste in the hangings and the furniture . . . You see that all these perfect appointments, these masses of valuable nicknacks, and this crowding of treasures upon the walls, are the long result of time. The story of many quiet, happy, active years lies, plain reading, before you. The folios, books, and albums; the musical instruments, the proofs and finished plates, the costly presents – tributes, from far and near, from strangers and from loving hands; the pug superbly cushioned in a corner by the armchair of the lady of the house, whose loving spirit has followed every footstep of the illustrious son (as much a boy to her now as when he tripped home daily from the Lycée Charlemagne) and finally Gustave Doré himself, who comes forward from an inner sanctum to greet you, a pencil in one hand and a cigar in the other, – make a delightful impression on the mind of the visitor . . .
>
> Doré makes no mystery of his art, like so many *poseurs* who are not worthy to light him to bed. He is open to discuss his plans with any friend for whose opinion he has the least respect. He is thankful for a suggestion; if it touches him his fine penetrating eyes are raised from the drawing and fixed intently upon you. His earnestness never knows abatement . . . You can seldom tempt him out of the realms of art. It is his work and his play.[1]

Soon after he moved to the rue Saint-Dominique, Doré had a studio built for himself. The façade, framed by two fragments of the frieze of the Parthenon, may still be seen in the rue de Bellechasse. A glazed passageway linked the building to the *hôtel*. Doré had 'always desired to address the great body of his

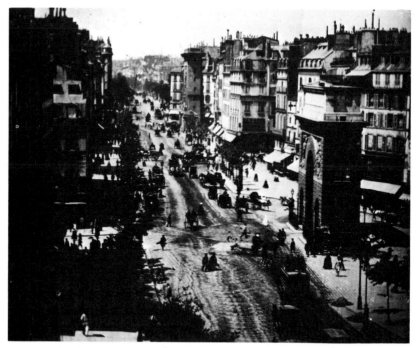

The Paris Boulevards. From a photograph by W. England, 1859

fellow-countrymen, and of the public of foreign lands'.[2] He wanted to be an artist of the people, rather than the artist of the wealthy. He was so full of creative energy, so jealous of any rivals, that he could not refuse a commission. His vignettes for *Le Journal pour rire* re-appeared as a wallpaper pattern. From the beginning of his life in Paris, he produced books and weekly cartoons. Philipon's publishing house, Arnauld de Vresse, brought out several works of his youth, with texts by the artist. A number of albums followed. The most successful was probably *Désagréments d'un voyage d'agrément*. Doré was still ebullient and unhurt by life.

The Crimean War established him as a popular artist. Henry Vizetelly recorded how, during the war, he and Bogue, the publisher, had founded the *Illustrated Times*. They had enrolled a pleiad of artists, including Hablot Browne (or Phiz), and 'Gustave Doré, then a young artist, whom Philipon, late of 'the Charivari,' had just introduced to the Parisian public.'[3]

Doré's contract with Philipon had expired in 1852, but he had joined him in a new and promising enterprise. *Le Musée Français-Anglais* was a monthly journal which published bulletins from the Crimea, with pictures of famous incidents in the campaign. Unlike Constantin Guys, a pioneer among war artists, Doré worked at home from sketches and photographs. Henri Bouchot, writing at the end of the century, said that Doré's popular pictures of the war showed 'the enormous distance which separated Raffet from this fanciful and very unscrupulous artist, so out of touch with life.'[4] But the journal was published simultaneously both in England and France; and, as Ollier was to recall, 'it spread the artist's name over the two countries more particularly concerned, and doubtless helped to maintain the war feeling of the time. To the same period belongs a comic history of Russia (1854).'[5] Doré had not grown out of his crude schoolboy humour, and he showed his persistent sadism. *Histoire pittoresque, dramatique et caricaturale de la Sainte Russie* was clearly an early work, and it still revealed the occasional influence of Töpffer. Its five hundred engravings also revealed a sense of spontaneity, grotesque farcicality and abundant fun. It remains a quite astonishing *tour de force*.

In 1852, at the age of twenty, Doré had undertaken to illustrate the historical novels of Paul Lacroix. He was now producing an enormous output of cartoons and illustrations. Since he cared much more for fame than he did for money, he was often poorly paid, and he flooded the market with his work. He was adept at lithography, but by far the greater part of his illustrations were wood engravings. He saw how some of the effects of painting itself could be reproduced by using graduated black and white. He gathered a group of engravers round him whose signatures became almost as celebrated as his own. He was well known, but in 1854 he became triumphantly famous with the publication of his Rabelais.

<div align="center">★ ★ ★</div>

Doré had had all the trouble in the world to get a publisher to accept these drawings. Luckily Paul Lacroix had seen them, and shown them to the publisher Bry – who had taken them out of

deference to Lacroix rather than conviction of Doré's talent. The Rabelais was cheaply printed on thin coarse paper, and the drawings – one hundred and eighty-nine of them – were not seen to their best advantage. They still caught the medieval spirit. Brilliant, exuberant, full of monstrous, unending nonsense, of ferocity, gaiety and gusto, they established Doré as a book illustrator.

Among his most ardent supporters was Théophile Gautier, the pre-eminent art critic of the time. On 16 May 1854 he expressed his unqualified delight.

> We opened the book and stood dazzled [he wrote in *La Presse*], because we had just stumbled on a genius, a spontaneous, violent and naif genius, fantastic and pictur-esque, comic and terrible; in fact an original genius, worthy of slipping his sketches between the pages of Rabelais . . . What invention, what fire, what verve, what prodigality, what spirit and sagacity! M. Doré is not twenty-two, . . . and he seems to have rediscovered the pencil which scribbled the astonishing chimeras of the comical dreams.[6]

<p align="center">★ ★ ★</p>

Rabelais was the first classic which Doré had illustrated, and it created a sensation. Yet already, in the early 1850s, he was dissatisfied with the mere illustration of books. Already he longed for recognition as a serious painter. If his energy alone could have won him recognition, he would certainly have been recognised. His sustained power of work was greater than that of any other artist of the age. But he lacked schooling, and he lacked judgment in his painting. He was never to learn that a topical or dramatic theme, a picture of exceptional size, was not necess-arily good art. Doré was a remarkable literary artist; he was perhaps unsurpassed as an illustrator of books. Pure art was not his vocation; he seems, from the first, to have lacked the gift.

He remained stubbornly blind to his failing. He had first exhibited at the Salon in 1848 – at the age of sixteen. At the Salon

Théophile Gautier. From a photograph by Nadar, c. 1856

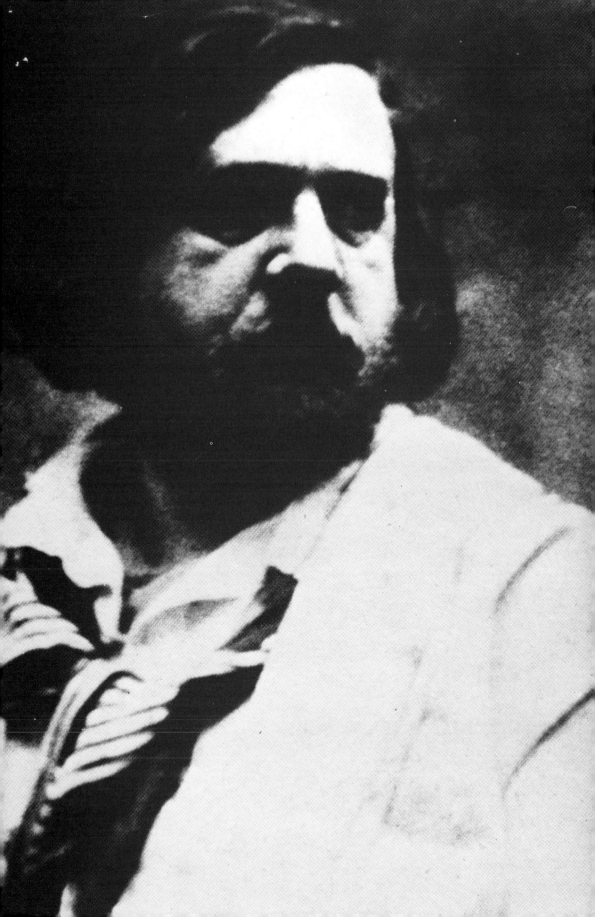

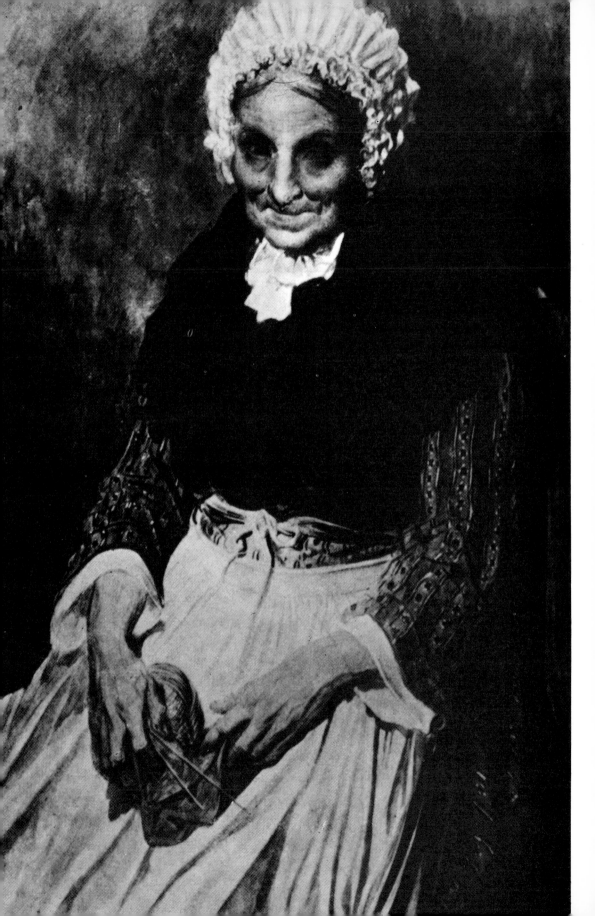

of 1854 he exhibited *L'Enfant rose et l'enfant chétif*, and *La Famille de saltimbanques*; the pictures were not even mentioned by the Press. In 1855 he submitted eleven pictures for the exhibition which was held as part of the Exposition Universelle. Gautier showed generous tact:

> In his *Battle of the Alma*, M. G. Doré has departed from his usual dispositions. . . . The Zouaves are climbing the steep mountainside with tumultuous impetuosity, over-throwing the astonished Russians. The upward surge of the valiant cohort is very well suggested . . . The execution is much too swift, . . . and from certain muddy tones one would think that the artist had not even taken time to clean his brush. Yet *The Battle of the Alma* is not mediocre, it contains life, energy and will.
>
> M. G. Doré possesses one of the most wonderful artist's constitutions that we know . . . His studio is bursting with enormous canvases, sketched out with a fury which exceeds that of Goya, then abandoned, then resumed; and in them, in a chaos of colours, there sparkle details of the first order: a head, a torso, a doublet, carried off as Rubens, Tintoretto or Velasquez might do. We do not know if M. Doré will ever free himself completely from the clouds which obscure him; but, from this moment, through the mists, there shines a ray of genius. Yes, genius, and we are not extravagant with the word. It is understood, of course, that we are only talking about the painter. The draughtsman has already found his place.[7]

Edmond About was also kind. 'My dear Doré,' he assured him, '. . . your *Battle of the Alma* is an original work . . . Your *chasseurs à pied* and your zouaves are fighting with noble fury; you were born to retrace these fiery struggles, these hand-to-hand fights, this intemperance of courage: you are yourself a zouave of painting.'[8]

The painter persisted. So did the artistic journalist. Doré contributed to *L'Illustration*. He drew for *Le Petit Journal pour*

Portrait of Françoise by Doré

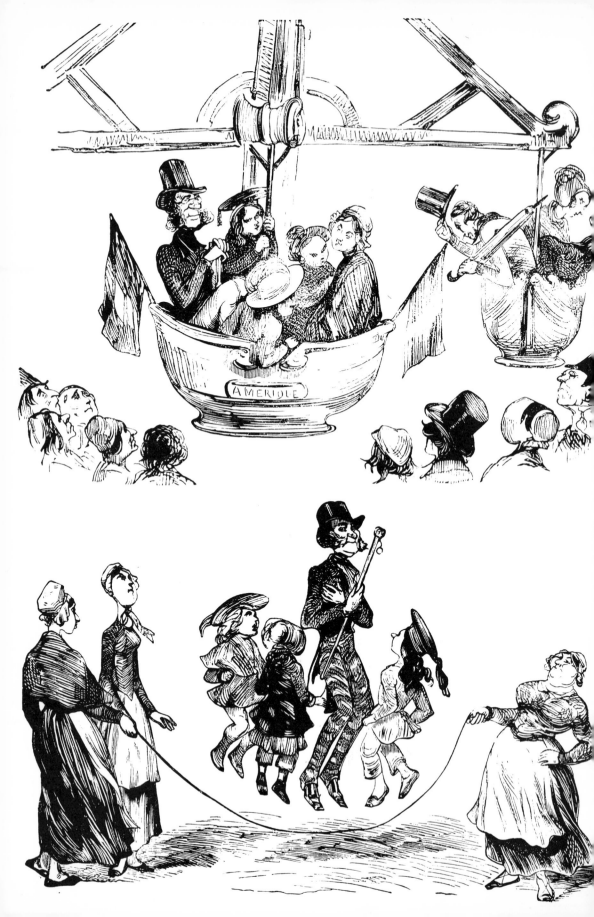

rire, which was edited by his friend Nadar. He was later to draw the headpiece for *L'Aéronaute*, the journal of Nadar's Société pour la locomotion aérienne. Doré designed the title for *La Gazette de Paris*. He produced lithographs of Parisian life, sometimes in colour, and sometimes closer to cartoon than they were to reality. Early in 1855 occurred an event which touched his sombre romantic imagination. In January Gérard de Nerval, the Romantic poet, was found hanged in the rue de la Vieille-Lanterne. No-one knows for certain whether his death was murder or suicide; but it haunted Doré, who made a lithograph of the event.

The recorder of contemporary history was enthralled, that summer, by Queen Victoria's State Visit to France. Blanchard Jerrold, the English journalist and man of letters, was to remember how Doré,

> then almost a boy, travelled with me to Boulogne to be present at the disembarkation of the Queen of England . . . He was delighted with his holiday, and the companions of his journey will long remember him taking his coat off on the sands and rolling about like a young scholar just let out of school. Nor will the same companions forget how the boy artist spent the evening, covering broad sheets of paper with portraits, caricatures, and fanciful sketches of scenery; all dashed off by the broad strokes of what appeared to be the most audacious of pencils . . . I have seen an effect by Landseer, made with the snuff of a candle; I have marked Etty rounding a dimple with his thumb . . . ; but for that force, which is exquisite in the perfect ease that is shown in its use, no sketcher with pen or pencil has ever surpassed the light-hearted, free-handed artist who carried away faithful records of a Royal landing in his waistcoat pocket.[9]

SCENES IN THE CHAMPS ÉLYSÉES

Top: AERIAL VOYAGE. Exceedingly cheap, and very agreeable – to those who have not the slightest tendency to dizziness in the head, or sickness in the lower regions.

Bottom: Family exhibition of feats of agility and skill on the long rope.

(*Two Hundred Sketches, Humorous and Grotesque*, 1867)

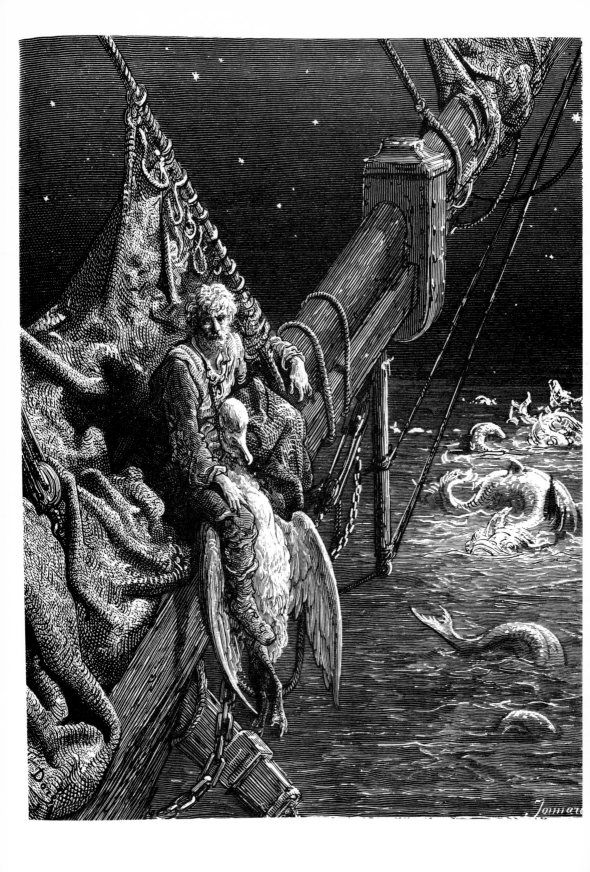

II

'The full altitude of celebrity'

1855–1870

4

The great epoch of Doré's life in Paris was the decade or so which followed the publication of his Rabelais: from the mid-1850s to the mid-1860s. His versatility and his technical skill seemed to be unlimited. So did his energy. One of his family later told Blanche Roosevelt:

> I do not think that during a whole year Gustave slept on an average more than three hours of the twenty-four. The wonder is that he did not go mad, for really he went through enough to turn anyone's brain. His life was one continual come and go of publishers, authors, journalists, and the like, and of excitement that never abated. We all expected that his health would give way, for it did not seem possible that any human being could conceive and accomplish so much . . . Yet he never complained of any physical ailment, not even a headache, but only worked and worked and worked.[1]

Arthur Kratz confirmed: 'I have never known any other human being who slaved so persistently as he. He never seemed out of temper, was never ill, and rarely ailing. During those first years in Paris he performed miracles – that is all one can say. After our dinner, back he would go to work at his blocks by lamp-light, and keep at them sometimes till day dawned.'[2] Paul Dalloz, the editor of *Le Moniteur universel*, remembered that Doré's life 'was one of extreme simplicity, like that of men who are jealous of all invasions of their working hours . . . But he kept a way open for friendship, and I shall always remember as an honour the affection he bore me.'[3]

It was with Dalloz and Théophile Gautier that, in 1855, Doré went to Spain. He always chose to spend part of his holidays in mountainous country which would recall the scenes of his childhood; but he wanted to see new lands and new peoples. In 1855 Hachette published Taine's *Voyage aux Eaux des Pyrénées*, with sixty-five of Doré's wood engravings. It is clear that he was

Alexander Dumas *fils*. From a photograph by Nadar

Les Landes (*The Pyrenees*, 1867)

at home in Spain; as he approached the Pyrenees, his landscapes are drawn with unmistakable conviction. One feels that he has seen the mountains and fir-forests near Les Eaux-Bonnes, that he has watched the climbers toiling up the pic du Midi. He has patently visited the chapel at Betharan; he has noted its twilit shadow against the mountains. He has travelled through the valley of Luz, he knows its plains and running rivers, its tall trees.

The year 1855 also saw the publication of the *Contes drôlatiques* by Balzac. Doré's four hundred and twenty-four pictures were no doubt inspired by his research at the Bibliothèque Impériale; but they were inspired, quite as much, by the landscapes of his childhood, the mountains, forests and ruined castles of his native Alsace. Doré insists, as usual, on the cruelty of the age; he also shows his exuberant fancy, his mastery of the burlesque, his patent pleasure in the Middle Ages. His sparkling, Rabelaisian illustrations show him at his most accomplished. Strangely enough, the book was unsuccessful in its day, and the edition had to be sold off cheaply. *Contes drôlatiques* is now among the most sought-after of all Doré's works.

In 1855 *La Chasse au lion* showed the marked unevenness of his illustrations. Written by Jules Gérard, the celebrated lion-killer, the book allowed Doré to express an unfortunate side of his nature. All his life he was to show an adolescent interest in violence. He revelled, here, in people being mauled, in lions being shot, or devouring dead horses. The following year he illustrated a book by Benjamin Gastineau: *La France en Afrique et l'Orient à Paris*. The pictures again suggested his concern with cruelty.

Doré worked unevenly; but he was still astonishingly versatile. In 1856 there appeared an English version of an ancient French romance: *Jaufry the Knight of the Fair Brunissende, a Tale of the Times of King Arthur*. Doré had adorned this with twenty engravings 'steeped in the glamour of faery'.[4] These re-appeared in 1858 in *The Adventures of St George, after his famous encounter with the dragon*. They appeared again, the following year, in *Boldheart the Warrior*. Here is Doré at his most romantic. A dragon crouches on a precipice, dangling a victim over the void. Armed men, amazed and horrorstruck, gaze up from the abyss; a castle rises from the mist-veiled crag. And here, again, is Doré in sadistic mood: here is a tree, and skeletons and bodies are hanging from it; birds of prey hover expectantly in the background. These pictures, and others, will re-appear, yet again, in *Geoffrey the Knight* in 1869. By this time the castles on their crags will have become the clichés of Doré's vocabulary, and he will seem, unconsciously, to caricature his own style.

The year 1857 saw his illustrations to the medieval legend *Fierabas*. At times they anticipate his pictures for *Orlando Furioso*; but they are still a good example of his early work. Their naivety is genuine. Doré already shows his mastery of light and shade, his extraordinary management of crowds. His lighting and composition prove his Romantic, abiding sense of theatre.

The plates to *The Wandering Jew* belong to 1856, but they were published in England in 1857. George Thornbury observed, in his Preface to the English version, that Doré was the most German of Frenchman; and [he] has something Teutonic in his width of vision. He is a broad-browed man; and his eye is as piercing as it is microscopic. Such breadth and such depth have seldom met before in a painter of dreams.[5] These dozen

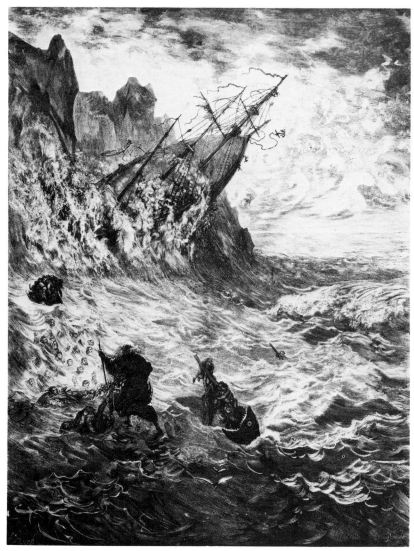

Shipwreck from *The Legend of the Wandering Jew* (1856)

plates were drawn when Doré was still afire with his visions, still enthralled by his work as an illustrator. His interpretations had not yet become dulled. Here, in the first plate, is Christ, on His way to Calvary, cursing the Jew, who sets out on his thousand years of wandering. In the second plate Isaac

Laquedem, on his journey through a mountainous region, passes a wayside cross, which recalls the divine imprecation. Centuries later, in a Brussels street, he is wandering still. He seeks refuge in a Flemish inn, but an implacable angel points him onward. He fords a river: no doubt the Rhine, for ruined towers rise on every steep. The very shine on the rippling waters assumes the shape of Christ on His way to Calvary. The Jew goes on, through a French graveyard, but his shadow takes the shape of Christ bearing the Cross; he reaches a Swiss valley, but 'demon faces glare from the boughs; every hole in the fir-trunk widens into an eye or a mouth . . . A white angel drives him forward on his path.'[6] In the medieval siege, for all the carnage, he finds no death. The stormy sea will not drown him, the serpents of the Andes will not poison him. Only when the Last Trump sounds is he released from the curse of Christ, into a world of monsters and devils. Doré's pictures for *The Wandering Jew* remain among his most impressive works.

Yet, even now, it was evident that Doré's inspiration occasionally outran his technique, that his drawing and his painting sometimes lacked artistic discipline. On 3 January 1857 *The Athenæum* recorded: 'His determination to be free from the trammels of Academies may, if he does not watch himself conscientiously, lead him into exaggerations and even to impertinences in Art . . . He is young, and has a career before him, that must not be endangered for the want of timely, and, at the same time, of friendly, warning.'[7]

The warnings were to be repeated on both sides of the Channel. Nadar dedicated his *Jury au Salon de 1857* 'To Gustave Doré in token of stupefaction'; but Edmond About, reviewing the Salon, recognised that Doré was impatient, even arrogant; he showed too much disdain of academic rules, and even of nature. Doré had exhibited a large painting of the Battle of Inkermann. About found his work

not only bad, but culpable. It is not permissible [he wrote] . . . to break more arms with a stroke of the brush than the Russians broke with rifle shots, to strew men around like playthings on a battle-field, and to drown the glory of our arms in a multicoloured purée. I should forgive

PRIMA DONNA PRIMA TENORE BASSO PROFUNDO

GROTESQUE SKETCHES – Operatic and melodramatic
There they are! Three beautiful singers, and only cost £6,000 or £7,000 a year!
Why, it's ridiculously cheap!
(*Two Hundred Sketches, Humorous and Grotesque*, 1867)

M. Yvon or M. Horace Vernet for this crime of lèse-
Inkermann, I should forgive all those who have no epic
genius; but M. Gustave Doré is all the more abominable
because he has understood, composed and arranged his
battle like a master. His painting is a masterpiece. It only
needs to be painted.[8]

<center>★ ★ ★</center>

For all his criticism, About remained a loyal friend. Late in the
1850s he bought a house at Schlittenbach, near Saverne, in
Alsace. Doré and Paul Baudry, the artist, Dumas *fils* and
Francisque Sarcey often stayed at 'the Schlitte'.[9]
 Nadar, too, remained a friend. There was always open table in
his studio. In the boulevard des Capucines, Doré would rub
shoulders with Sardou, Dumas *père*, and the *sociétaires* of the
Comédie-Française. Several times in 1857–58 Nadar photo-
graphed Doré; and between the poses there was fencing. There
was always a mighty clatter of weapons in the studio. When, in

Prussian uniforms (*Histoire pittoresque, dramatique et caricaturale de la Sainte Russie*, Anon., 1854)

1858, Nadar made his first attempt to take photographs by artificial light, *le tout Paris* – Doré among them – assembled to watch the experiments on his terrace.[10]

Doré was a social lion, and Henry Vizetelly remembered

> the gay evenings there used to be at this period in Doré's studio. Frequently troops of artist-friends would look in, and there would be music and singing, fencing and boxing and *la savate*, gymnastics and circus feats, with amateur clowns posing on their heads and trotting about on their hands . . .
>
> Gustave Doré was the gayest and wildest of the mad party, and, indeed, until he was thirty he always seemed to be exuberantly happy.[11]

Taine remembered:

> At his mother's house in the rue Saint-Dominique, . . . he received once a week. Mme Doré, in black silk, her head folded in black lace, with most striking countenance and eyes of extraordinary brightness, sat at the fireside, receiving the visitors. As for Gustave Doré, he would be at a table drawing . . . One saw the figures take life under his pencil . . . Sometimes, at midnight, when he accompanied us to the street, he would execute feats of strength on the horizontal iron bar that held the gates.[12]

Doré revelled in the *Chansons* of Gustave Nadaud (he always asked him to sing 'Lorsque j'aimais . . .'). He was often seen at the Opéra in the rue Le Pelletier, where Meyerbeer, Rossini and Halévy reigned supreme. He was found with Delibes and Gustave Claudin, Lemercier de Neuville and Halévy, in the tiny foyer of the Bouffes-Parisiens (generally called 'the omnibus' because its habitués sat on two parallel benches). He frequented the Italiens in the place Ventadour, which saw the triumphs of La Grisi, Mario, Lablache and Alboni. A tune by Rossini was enough to make him quit his pencil. The Overture to *William Tell* would send him into ecstasies. His pleasure, like his ambition, was not half-hearted.

On 10 December 1858, Rossini held the first of his *samedi soirs* at 2, rue Chaussée-d'Antin. During the next decade almost every French and foreign musician and other artist of note attended one or more of his Saturday nights. Among them were Doré and his brother Ernest, Dumas *père*, Delacroix, Saint-Saëns, Gounod, Liszt, Meyerbeer, Patti, Sarasate, Sivori and Verdi. The guests were regaled with a curious selection of food, including delicacies which had been sent as presents to Rossini. There was macaroni made by nuns at L'Aquila, there were olives from Ascoli Piceno, *mortadelle* from Bologna, cheeses from Gorgonzola. Some people seem to have sought invitations merely to eat, 'but the real *clou* of the Rossini *samedi soirs* . . . was the conversation, the music, . . . the skits prepared and performed by such talented entertainers as Gustave Doré and Eugène Vivier.'[13]

Doré also became a friend of Jacques Offenbach: the composer who, more than any other, symbolised the spirit of the age. For fifteen years, during the Second Empire, Offenbach was possibly the most popular name in all Paris. 'How many joyful festivities,' wrote Victor Fournel, 'how many wild evenings, how many champagne suppers in that apartment at 11, rue Laffitte! It was always invaded by a real crowd after each new success! The dances overflowed the apartment . . . The neighbours could not think of sleeping. They decided to take part, and gaily joined in.'[14] Doré, added Fournel, 'could have been the first gymnast of Paris if he had not preferred to become the first draughtsman of France.'[15] At Offenbach's dances, 'people clustered round to see

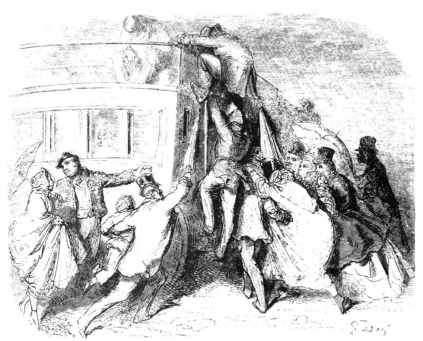

Omnibus de la Bastille (*Le Nouveau Paris*, 1860)

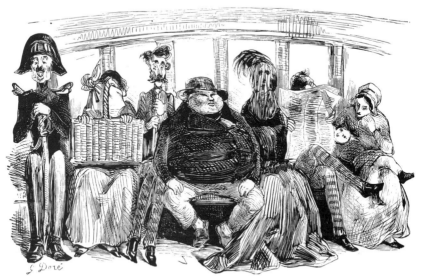

Interior of an omnibus – Agreeable choice of neighbours (*Two Hundred Sketches, Humorous and Grotesque*, 1867)

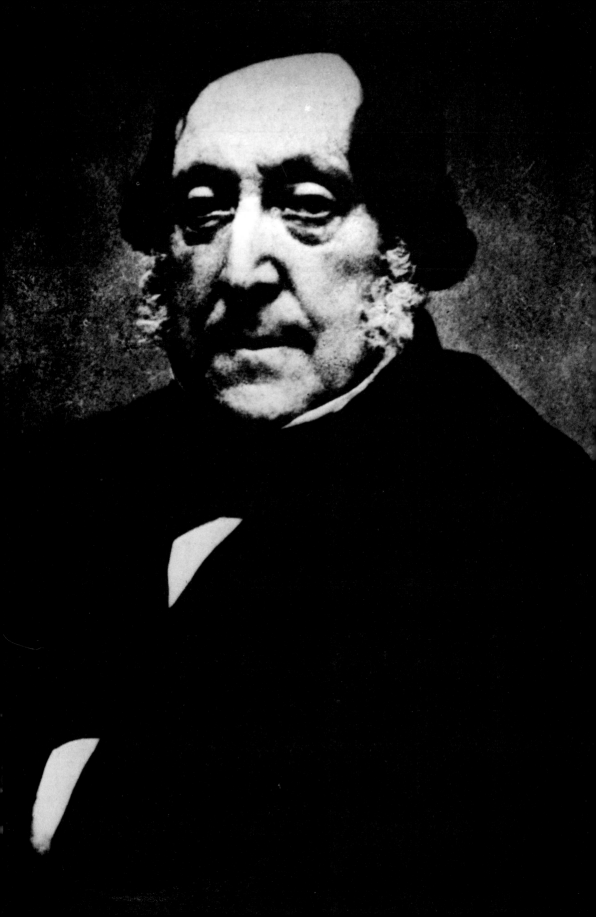

him execute his *cavalier seul* on his hands . . . He changed his costume two or three times an evening, and spent as much imagination on this work as he needed to illustrate Ariosto. People particularly remember his Meadow costume. It had lawns broken by pools, and round his hair there were insects and butterflies which flew off in all directions. One day he tried to disguise himself as Mephistopheles. He smeared his face with Veronese green and almost died of poisoning.'[16] In 1858, after the success of Verdi's *Il Trovatore* at the Opéra, Offenbach organised a private performance of a grand opera, *L'Enfant trouvère*. Edmond About took the part of the executioner, and Doré took the part of Léonore. At the ball which followed, Doré dressed up as a Pierrot, and Nadar appeared as a baby.

Doré was also a lively guest at Gautier's Thursday evenings at Neuilly.

> He usually made his entrance on his hands, his feet in the air [remembered Gautier's daughter, Judith]. He refused to say good evening until he had performed all sorts of *clowneries* . . .
>
> When la Présidente [Mme Sabatier, the courtesan] was there, he bore her off at once to the piano, and they improvised a duet of Tyrolean songs full of fantasy. He had a charming tenor voice, she had a pleasant soprano, and there were trills and flourishes and yodellings without end.
>
> One of Gustave Doré's fervent admirers, his closest friend, his foil and indeed his accomplice, was Arthur Kratz, an auditor at the Conseil d'État. Alsatian and a baron, he was a regular guest. My father claimed that he had the right to be preceded by four halbardiers . . . Gustave Doré was always teasing him about this . . .
>
> Gustave Doré carried his Machiavellian habits so far as to send Kratz to dine at Neuilly, and only arrive himself after dinner. When he arrived, . . . he organized experiments à la Robert Houdin, unearthed the most carefully hidden things, read sealed letters, guessed the thoughts that were whispered far away from him . . . He confounded and

Gioacchino Rossini (1792–1868). From a photograph by Nadar, c. 1856

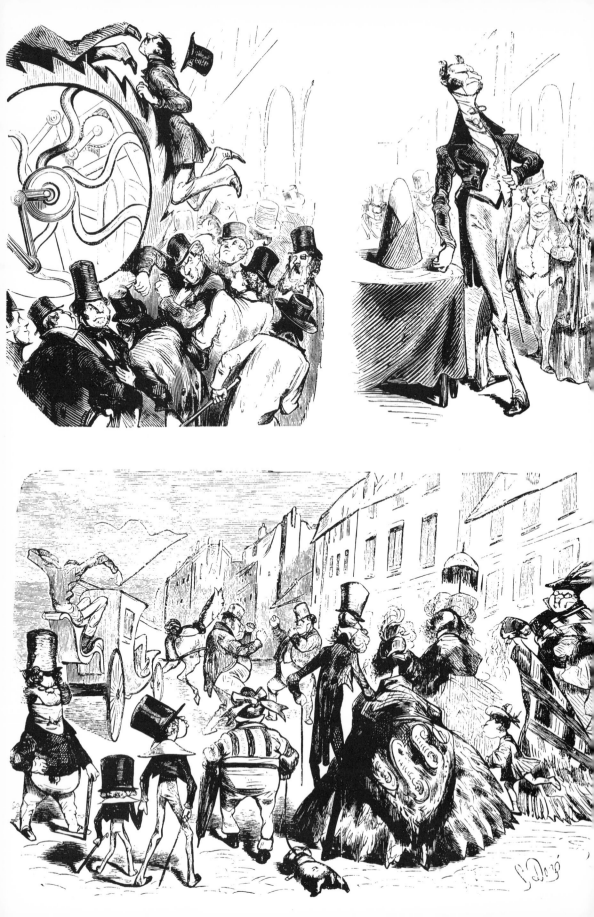

stupefied us. We did not suspect that Kratz, who seemed so detached, or so interested in a private conversation, was telling him aloud all he ought to know, . . . with the aid of words agreed in advance.[17]

★ ★ ★

The social lion who added a sparkle to the life of Paris continued to make comments on the contemporary scene. Some of his journalistic work is sadly disappointing. He recorded the Italian campaign; but his illustrations to *Géographie du théâtre de la guerre* sometimes suggested fashion-plates, and the picture of the *lazzaroni* in Naples hardly compared with Doré's later pictures of the London poor. The artist was working from notes; it was plain that he had not seen what he drew. All too often he seems to have been hard-pressed to fulfil commitments. His picture of the Prussian gunner, hussar and bodyguards was to re-appear in 1867 in a book on *La France et la Prusse;* so were his impressions of Belgian troops. His pictures of the Mexican war were patent journalism. His illustrations of the United States and Mexico showed plainly that he had never been to the New World.

Doré needs to feel at home, and to draw from life; and some of his most felicitous works are his illustrations to *Le Nouveau Paris* (1860). It is true that there are signs of haste; there are also delightful comments on Parisian life at the height of the Second Empire. Passengers fall over themselves to board the omnibus to the Bastille. A small child is restrained from joining the swans in the pond in the Jardins du Luxembourg. The fishermen near the pont de Grenelle grimace at the passing of a paddle-steamer. A bourgeois family take the air in their garden at Auteuil; and, at

CONSEQUENCES OF THE LONDON EXHIBITION
Top left: A shilling day. The Exhibition is much crowded. Machinery in motion, including a rotary saw, highly recommended by the inventor, and appreciated by the visitors.
Top right: An exhibitor expecting the advent of the Royal party.
Bottom: Effect produced on the outward appearance of the Parisians by their visit to London.
(*Two Hundred Sketches, Humorous and Grotesque*, 1867)

La culture des pêches à Montreuil (*Histoire des environs du Nouveau Paris,* n.d.)

the Théâtre Montmartre, the leading lady is addressed both by her official suitor, and by her admirers in the stage box. Some of Doré's most engaging works were his illustrations to the sequel: *Histoire des environs du Nouveau Paris.* At times he chronicles society in the style of Guys; but his sketches have an abundant and spontaneous humour which Guys did not show. The boating and rowing enthusiasts at Bougival and Asnières, the amateur *plein-air* artist at Fontainebleau, are observed with infectious amusement. 'L'amateur des roses à Fontenay' is an irresistible picture of Monsieur Prudhomme discoursing on the cultivation of flowers. 'La culture des pêches à Montreuil' is the perfect companion piece.

Doré's energy remained unending, and he did not confine himself to journalism. The year 1860 brought his illustrated version of *The Tempest,* his vigorous picture of the storm at sea,

Headpiece to *The Tempest* (Shakespeare)

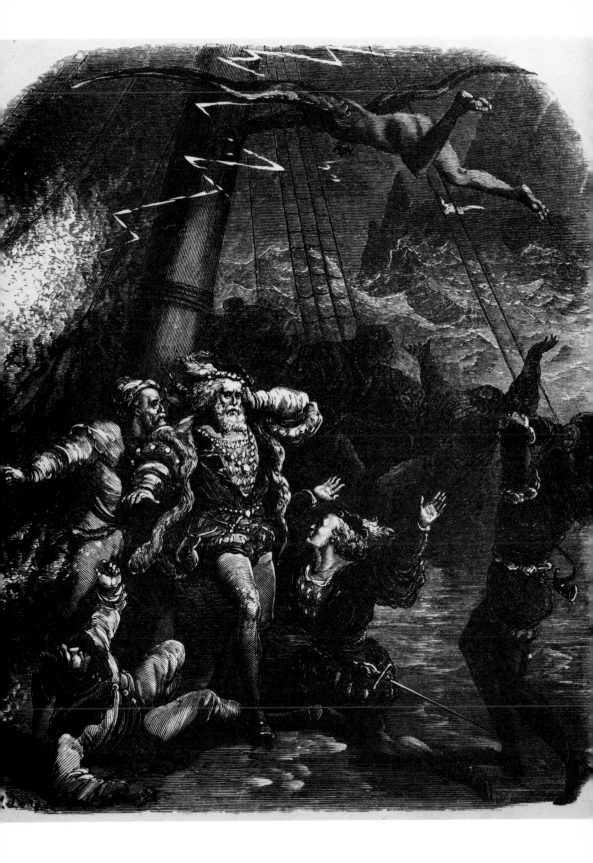

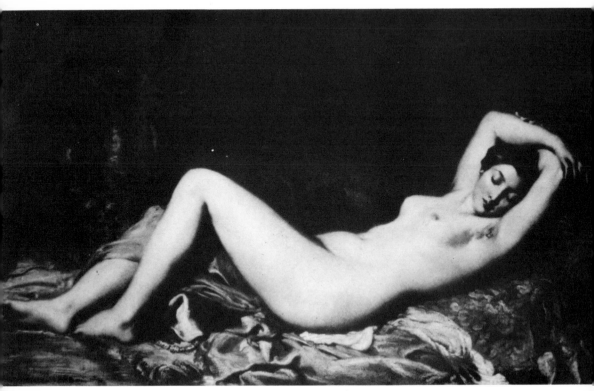

Baigneuse endormie – by Théodore Chassériau

his powerful Gothic portraits of Caliban and 'the vile witch,
Sycorax'. On 26 December, visiting the Charité hospital, the
Goncourts found a fresco by Doré. He had decorated the staff
room with 'a kind of Last Judgment of all doctors, past and
present, at the feet of Hippocrates'.[18]

In 1861 there appeared the fifth edition of *Le Roi des
montagnes*. This edition of Edmond About's work was illustrated
by Doré. At times he still showed too much delight in decapi-
tation and torture; but he had his moments of quiet humour and
of fantasy, and his moments of exuberant fun. He showed a nice
sense of character, and a power of conveying action which never
ceases to astonish us.

It was, however, with his illustrations to the *Inferno*, pub-
lished the same year, that Doré reached 'the full altitude of his
celebrity'.[19]

Doré had conceived the project in 1855; it was to be the first of a series of thirty classic works which he would illustrate. No publisher would bear the cost of this folio volume, and he had to pay all the expenses himself.

As the *Inferno* opens, Dante loses his way in a gloomy forest; the very briars hem him in, the roots of the trees writhe in anticipation of anguish. He journeys on, and reaches a lonely steep, where a panther attempts to check his progress. Then Virgil appears in the vast desert. The two move on, past fissured rocks and dead, leafless trees. They reach the gates of Hell, where Charon waits to ferry the damned across the Acheron. Minos, the infernal judge, sits in the second circle of Hell, where carnal sinners meet their punishment. In the third circle, the gluttonous lie in the mire, until Cerberus devours them. Dante and Virgil descend to the fourth circle, then to the fifth, where the wrathful and gloomy are tormented in the Stygian lake. They continue their grim descent until they reach the ninth circle, where traitors suffer the torture of ice; and here, in the ultimate depth of Hell, is Lucifer, who leads the travellers back again to earth.

In the *Inferno*, Doré is at liberty to show theatrical, inventive cruelty. He does so with a nightmare conviction, in an underworld of brooding crags, in a world which has no sun or moon or stars. Yet Blake, as Millicent Rose observed, 'had an urgent sense of evil and damnation; he loved and hated deeply. Doré lacked Blake's adult moral sense, and this lack circumscribed his Hell. This work was well regarded in its time, among people who enjoyed melodramatic sensationalism . . . But it does not stand through the centuries with the two great versions of Dante, with Blake and Botticelli.'[1]

Doré's *Inferno* was to be published in England in 1866. Two years later he was to publish his illustrations to the *Purgatorio* and the *Paradiso*. Altogether there were to be 136 illustrations to Dante. It was a remarkable number, considering the range of their conception. But Doré's visions of Purgatory and Paradise were, predictably, to be less heartfelt than his savage vision of Hell. Their 'more than thousand splendours', their celestial

figures appearing on rays of sunlight, show only his religiosity, his period sentimentality, his sense of theatre, his sense of design run wild.

However, in 1861, his *Inferno* created a sensation. It was now, on Mme Doré's insistence (so the legend goes), that Paul Dalloz took a copy of the book to the Minister of Public Instruction, and asked that Doré should be decorated. By an imperial decree of 13 August, 'Mr Doré, Dessinateur, auteur du *Dante illustré*', became Chevalier de la Légion-d'honneur.

On 15 November Émile Montégut reviewed the *Inferno*. This long and serious appraisal in *La Revue des Deux Mondes* re-affirmed that Doré was accepted by the Establishment. Doré, concluded Montégut, possessed in the highest degree what might be called a passive imagination. This imagination 'tried not so much to create as to understand, and it created only by interpreting'.[2] Modern commentators have been less kind. Michael Marqusee observes that Doré 'was never a profound or even a critical reader. He could make no use of the poem's richness of tone, or of its historical background. The figure of Dante was for him only a device for stringing together the interesting people and horrible visions.'[3]

<p style="text-align:center">* * *</p>

More than once, Doré repeated on canvas a theme which he had treated as an illustration. In the Salon of 1861 he exhibited a painting which had been inspired by the *Inferno*: 'Dante and Virgil, in the ninth circle of Hell, visit the traitors condemned to torture by ice, and encounter Count Ugolino and Archbishop Ruggieri.'

Gautier gave him generous praise:

> He rivals in fear and horror the poetry of Dante . . . A polar night extends its black crape across the eternal ice. With convulsive efforts, the damned break through the thick crust which enshrines them, but the bitter cold promptly re-creates their prison. Ugolino emerges down to the shoulders from the half-open ice; he gnaws the skull of Archbishop Ruggieri . . . The fast in the

tower has given him this horrible appetite, and he is not difficult to please . . .

What a sense of reality! What a visionary and chimerical spirit! Being and non-being, the body and the spectre, day and night: M. G. Doré can render everything. It is to him that we shall owe the first illustration of Dante, since Michaelangelo's has been lost.[4]

Maxime du Camp also assessed the painting in the Salon. 'I shall not,' he concluded, 'ask M. Doré to purify his taste, that is to say to renounce the violence which is really part of his nature. I should, however, like him to acquire a taste for beauty.[15]

<div align="center">

* * *

</div>

In his new studio in the rue Monsieur-le-Prince, Doré worked on. *Aventures du Baron de Munchhausen* was published in 1862. Newly translated by Gautier's son, it was introduced by Gautier himself. He emphasised the strong Germanic flavour of the stories, the bizarre, exaggerated humour, the logic of absurdity carried to its limit. No-one, declared Gautier, was better suited than Doré to illustrate the Baron's adventures. No-one knew better than he did 'how to animate chimeras, dreams and nightmares . . . and all the monsters of fantasy, with a deep, mysterious life, . . . and the text thereby acquires a cold buffoonery which is more Germanic still.'[6]

Alsatian by origin and by temperament, Doré felt at home with these Germanic tales. They allowed him to illustrate the wildest fantasy: the baron's horse tired to the steeple, the baron shooting seven partridge with a single shot, the baron attached by a rope to the moon. Doré revels in the crude and the grotesque: the underwater world, the monsters of the deep, and the natural functions of the body. But by far the strongest emotion is cruelty. *Baron de Munchhausen* seems to encourage all the sadism in Doré's nature. The Baron nails a fox to a tree, and flogs his entrails out; he blows up a bear, he tears the guts out of a wolf. A cannon-ball decapitates sixteen soldiers, and lands in the gaping mouth of a peasant woman. Her husband forces it down her throat with a mallet. It is true that these illustrations only under-

line the text; but they are drawn with decided gusto.

The year 1862 also saw Doré's illustrations to the *Contes* of Perrault. He had undertaken the work in order to refresh himself after his grim, protracted labour on the *Inferno*. In the *Contes* he made himself gentle, almost childlike, to illustrate the fairytale aspect of the book. The *Contes* begin with an old woman reading to a cluster of children round her chair. Their eyes are open wide, they are wrapt in legend, fearful of interruption: so fearful that one child puts its fingers into the mouth of its *pulcinello* to silence it. Doré's love of children is evident. His picture of the minute Tom Thumb marking his trail through the forest is among the most poignant of all his illustrations. Doré does not avoid cruelty, even in this book; there is an ugly detail in *Puss-in-Boots* as an ogre sits down to a dish of children. But if Doré's Perrault is sometimes grim, it remains unusually touching, and at moments it is magical. Sainte-Beuve considered it a gift-book fit for a king. He wondered if every small boy had become a Dauphin of France.

<p style="text-align:center">★ ★ ★</p>

In 1862 Doré paid a visit to Baden. During the fortnight of the races, so Gustave Claudin said, Baden was the land of milk and honey. 'On the day of the Grand Prix, the race-course at Baden looked exactly like the one at Longchamp. The only thing that was different in the picture was the Grand Duke of Baden's scarlet livery. In the evening, at the theatre, one found the artistes of the Opéra, the Opéra-Comique and the Comédie-Française, interpreting the great repertoire . . . It was nothing but hunts, races, banquets, concerts and gala performances . . . They gambled like hell.'[7] The elegant and idle of every capital used to congregate in Baden. In the evening, before the gambling began, people strolled on the lawns of the Maison de Conversation, and happily carried flirtation to its limits. Many Parisians had country places at Baden Émile de Girardin, the Press magnate, had a chalet there, where he received his colleagues in journalism – and the whole Press was at Baden, too.

Méry, the Marseillais wit and writer, was also there, for his one

The waters of Baden – Baden castle (*Two Hundred Sketches, Humorous and Grotesque*, 1867)

passion was gambling, and in Baden he was busy losing all that he had earned by his pen. He had so taxed his eyes that he was now nearly blind. He could only read with the aid of a magnifying glass, and he could only walk if he were escorted by a friend. Claudin and Doré used to guide him round the Baden streets. Doré, remembered Claudin, 'was a great gambler. Like Méry, he had a system, a procedure which he had studied, and from which he expected results. He always lost, and then he would be overcome by fury, and throw his gold on the floor . . . This passion for gambling, which he felt only in Baden, cost him very dear.'[8]

However, almost as soon as he arrived in Baden this summer, Doré won 10,000 francs at roulette. He promptly arranged a *déjeuner* in the ruins of the old castle. Destroyed by the French in the War of the Palatinate, the castle was now a tourist attraction.

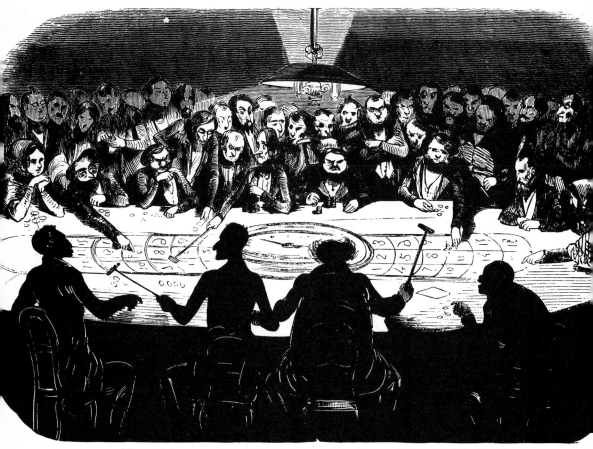

View of the room in which they play at Roulette at Baden. This is the place greatly affected by patients suffering from diseases whose cure is dependent on the mind being kept very quiet and free from all excitement. (*Two Hundred Sketches, Humorous and Grotesque*, 1867)

Grand Duke Leopold had had the ruins preserved, and Aeolian harps were set here and there at vantage points to make music in the breeze. Among the guests at Doré's celebration were Pauline Viardot, the operatic soprano, and her husband Louis, the man of letters. Doré froze them with terror by walking round the parapet of the castle on his hands.

It was with Louis Viardot, an expert on Spanish literature, that he studied the next subject which he was to illustrate. Viardot's translation of *Don Quixote* appeared in 1863, with three hundred

and seventy-seven illustrations by Doré. Before he did them, Doré spent three months in Spain. He brought back a quantity of pen-and-ink drawings which he used in his work. Apart from a Gothic detail which might come from Strasbourg rather than Seville, the illustrations have an unmistakable Spanish atmosphere. Here are the shaded balconies, the stark sierras and the Pyrenees, the suggestion of grandee pride. Here, too, is a compassion which Doré does not always show in his illustrations. Even in his most ludicrous, most disastrous moments, his Don Quixote is drawn with admiration, even with a sort of tenderness. There is a certain element of caricature in the thin and venerable knight with his plump, plebeian companion, Sancho Panza. Yet the caricature never eclipses the sense of dignity, the sense of humanity. Don Quixote moves in a world both romantic and realistic: a world of archaic windmills, sumptuous castles, bleak landscapes and crude poverty. He is at once a caricature and a symbol.

It is, as usual, possible to criticise the anatomy of Doré's figure; and here and there, in *Don Quixote*, one suspects a reminiscence of Murillo, a debt to some familiar Spanish painting. But the sadism which is so often marked in Doré's illustrations is almost absent from his *Don Quixote*. The element of the grotesque is kinder than it was in his illustrations to *Munchhausen*. If there is social criticism in his pictures of the poor, it is comparatively gentle criticism. His powers of invention are astonishing. His illustrations show an extraordinary richness and vitality, a concern for detail, for physical action and, above all, for mood. Some of the motifs may become clichés in Doré's later works, but here they are fresh and inspired. His mastery of composition, his ability to make black-and-white speak like colour, indeed to make colour almost unnecessary, have never been so manifest.

One of the handsomest tributes to his latest book was written on the last day of the year:

Monsieur,

I have spent two nights looking at the illustrations to *Don Quixote* and I want to tell you the extreme pleasure which they have given me. I was already delighted by most of the

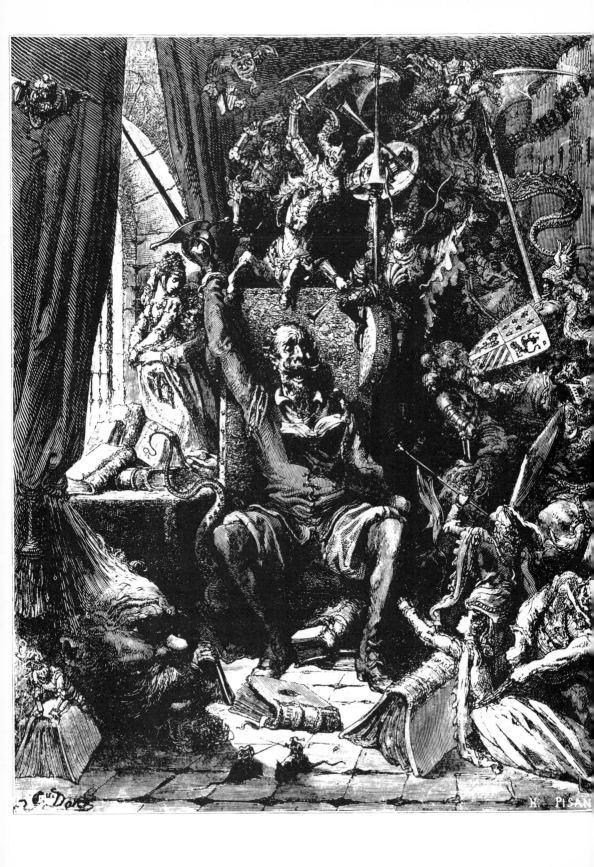

subjects in the *Contes des fées*. I could only leaf through the Dante at random, but it seemed superb to me. As for the *Don Quixote*, which I now possess, I have followed it so that I know it by heart and keep all the pages in my memory. It seems to me to be a masterpiece. What a powerful and entrancing imagination you have, what life, what a feeling for men and for their thoughts, for things and for their expression! I admire with all my heart, and I owe you not only some sweet moments, but a deep and lasting impression which is bound in me to the aspect and the meaning of Cervantes' masterpiece. It is a noble translation, charming and very faithful, for it is both comic and grievous, heart-rending and amusing, and the landscapes and the architecture, the costumes and the details of every kind, down to the thistles, rags and chickens: everything has wit, humour and drama. May you live long, Monsieur, and work much, and may heaven, hell and the world pass through your hands. You will have raised your generation by a degree, and you will have made it artistic.

GEORGE SAND.[9]

'A world of disorderly notions, picked out of his books, crowded into his imagination'. Don Quixote in his library (*Don Quixote*, 1863)

6

In the intervals of frenetic work, Doré's social life continued. On 20 March 1863 the Goncourts had met him at a *soirée* at the Louvre. It was given by Émilien de Nieuwerkerke, Surintendant des Beaux-Arts and lover of the Emperor's cousin, Princess Mathilde. At midnight, when most of the guests had gone, the habitués had watched Eugène Giraud drawing a caricature of Doré, and drying the touches of watercolour over the lamp.[1] On 4 January 1864, Doré dined with the dramatist Ernest Legouvé; among the other guests were Gounod, Meyerbeer, and Victorien Sardou, who found Doré 'strange, nervous, teasing, paradoxical and vivid as ever'.[2]

Doré was among the most constant visitors at Adelina Patti's Sunday evenings, when (reported her companion), 'he delighted everybody by his clever Tyrolese songs, and even made Adelina break through her rule of never singing at private parties'.[3] The artist who was at home with Patti in the Champs-Élysées was also a guest at the rue de Courcelles, where Princess Mathilde reigned over a glittering *salon,* and talked with a host of painters, sculptors, amateurs and critics of art. In December 1864 Doré was invited to one of the *séries* at Compiègne. During the ten days he spent as the Emperor's guest, he composed some of his famous *tableaux vivants;* they included *Solomon and the Queen of Sheba,* with Nieuwerkerke as Solomon, and the Baronne de Poilly, one of the Empress's ladies-in-waiting, as the Queen.

Doré himself was at home every Saturday in the rue Saint-Dominique. His mother sat in a chair of state to receive the guests. She wore a turban, and dressed in a sort of semi-Moorish, semi-Andalusian fashion. Paul Lacroix said that she always looked like an accomplished gipsy. On certain grand occasions Chevet – the most prestigious food store in Paris – sent in an army of cooks and assistants, and they devised new dishes in honour of Doré's latest illustrations. One evening – for Doré still remained '*un gamin de génie*' – an outsize *pâté de foie gras* was cut, and out flew a tiny bird, which was followed by a guinea-pig. Another time the red wine was decanted in carafes which were really musical-boxes. As soon as these were lifted,

they began to play. Doré himself was not tempted to try the contents. He drank nothing but Roederer champagne.[4]

In social life, as in his work, he showed a sense of theatre. Sometimes he and his friends performed charades. On 8 May 1864, Louis Lemercier de Neuville, the ventriloquist, entertained the guests with his *pupazzi*. These puppets represented famous people, among them the Dumas, *père et fils*, Hugo, Offenbach and Rossini. On 16 April 1865, Lemercier de Neuville returned to the rue Saint-Dominique. Doré collaborated with him, and painted a series of panels with cartoons of his friends; he also painted a backdrop of 'gross women'.[5] The performance was a triumph; so were the *tableaux vivants*, which were illuminated by Bengal lights. The prizes in the tombola showed a curious sense of humour: they included stuffed fish, pairs of clogs, and pickled herrings. They also included a bottled foetus.[6] Modern psychiatrists, observing the backdrop and the foetus, might reflect on Doré's state of mind.

* * *

Since, as a young man, he had been rejected, Doré had set aside the thought of marriage. He had remained the subject of endless gossip. 'By public report,' observed his biographer, Blanche Roosevelt, 'he had been successfully betrothed and married to a great many female celebrities ever since his *Rabelais* set Paris talking about its young illustrator. At one time it was alleged that he was madly in love with Adelina Patti, and had threatened to kill himself in her boudoir.'[7] One may question the threat of suicide, but Doré had clearly been devoted to her. Shortly before her engagement to the Marquis de Caux, he had 'besought her to let him take her portrait; and soon two splendid half-length pictures appeared in his studio. They were masterpieces,' wrote her companion Louisa Lauw, 'both as to colouring and drawing, but it was difficult to discover a likeness in them to the original.'[8] *La Vie parisienne* recalled one of these pictures. It showed 'the laughing Mlle Patti herself, a circlet of gold in her black hair, a red rose behind the ear, her shoulders emerging from the glossy satin of her bodice.'[9] Blanchard Jerrold was no doubt referring to the same picture when he wrote that 'there was the most delicate

and highly-finished portrait of a prima donna, apart upon an easel, for some time. But it suddenly disappeared – the lady had married. A tender chord had been broken.'[10]

At another time, records Blanche Roosevelt, it was said

> that Doré's assiduities at the feet of Christine Nilsson had compelled the fair Swede to forbid him her house; again, that he adored Hortense Schneider, and I don't know whom besides. But the fact is beyond question that he gave Paris no real occasion to talk of his love affairs with one exception, in the case of a celebrated and extraordinary woman, whose eccentricities even to-day keep her name before the public much more prominently than her talent. This caprice lasted nearly two years . . . He was never really in love with her; but she was the fashion.[11]

This extraordinary woman was, it seems, the courtesan Cora Pearl. Her biographer claims – though he does not give authority for his statements – that 'the association began in 1868, lasted for two years, and Doré and Cora are said to have contemplated marriage.'[12]

Some time between 1859 and 1869 we may also place Doré's love-affair with a more engaging courtesan.

<div align="center">

★ ★ ★

</div>

Julie-Justine Pilloy, better known as Alice Ozy, was endowed with wit and elegance, and with a very keen financial sense. One of her grandfathers had been director of the Conservatoire, and chapel-master to the Emperor; she had also inherited an artistic nature.

She was born in Paris on 6 August 1820, the daughter of Monsieur Pilloy, a jeweller, and his wife. Since Monsieur Pilloy took a mistress who bore him two children, and Mme Pilloy consoled herself with a lover, Julie-Justine was entrusted to a foster-mother. At the age of ten, since both her parents found her

The prosperous bourgeoisie: Madame Pillay,
the former Alice Ozy, in her mid-60s

66

an encumbrance, she was forced to earn her living by embroidery; and in a Paris attic, with her foster-mother's daughter, she spent the long days of her childhood doing needlework. The woman who employed her suddenly became aware that the girl's classical beauty would draw customers to the shop. At the age of thirteen, Julie-Justine was installed behind the counter. She was soon seduced by the owner of the establishment; this seduction lost her the chance of a bourgeois marriage, and she decided that she must find her happiness elsewhere.

She found it in the arms of Paul-Louis-Édouard Brindeau, a future *sociétaire* of the Comédie-Française. Julie-Justine fell in love with the young actor, and eloped with him; she naturally turned towards the theatre. Early in 1840 she made her début at the Variétés. Whether she was content to act, or dreamed of being a courtesan, she had to choose a professional name. She adopted her mother's maiden name, and became Alice Ozy.

She was both innocent and shrewd, romantic and sensible, and it was practical politics, quite as much as romance, which dictated the next episode in her life. King Louis-Philippe and Queen Marie-Amélie summoned the company from the Variétés to give a command performance in honour of their son, the Duc d'Aumale. The Duc was nineteen, handsome, and just back from the North African campaign, in which he had commanded a regiment. He saw Alice at the Tuileries, and fell in love at once. Alice left Brindeau, and became a royal mistress. This liaison established her in the first rank of courtesans.

The Duc d'Aumale was followed by the Comte de Perrégaux, the son of the King's banker (who left her for Marie Duplessis, the future Dame aux camélias); the Comte was followed by Charles Hugo (she rejected his father, the poet), and by Théodore Chassériau, the painter: the only man she seems to have loved. At some time she appears to have been the mistress of the Duc de Morny. In 1855 she retired from the theatre, and allowed herself a surprising liaison: she was kept for twelve years by a rich man who made no physical demands of her. This was fortunate, for in 1858 she had an affair, in Rome, with Edmond About. He made her the heroine of his novel, *Madelon*.

As her last lover, she took Gustave Doré. She was twelve years older than he was. Doré needed a maternal mistress. Blanche

Roosevelt says that there were rumours that he might marry Alice; but he continued his solitary life. 'He would have left any woman in the world at a word from his mother.'[13]

<p align="center">★ ★ ★</p>

Such rumours of marriage kept Paris talking, but they were baseless. Doré was a Bohemian in his love-affairs, but he was an idealist at heart. Once, it is said, in his mature years, he fell desperately in love; but 'the *grande passion* about which he talked and wrote, and which really troubled his repose and made him unhappy for a time, was a dream that never . . . took the shape even of a declaration.'[14] Among his sketches, Blanche Roosevelt found 'a woman's face often times repeated. It is very beautiful, and one that he must have been very fond of to have had it so constantly in his memory . . . I have an idea that it may be a portrait of his second idol . . . It is not to be wondered at that he lost both head and heart to so charming a person.'[15]

Once again, in middle age, Doré thought of marriage; and this time, says Blanche Roosevelt,

> things went rather far. His betrothed was all that could be desired as regards birth and position, and the match was thought in every way a good thing . . .
>
> All manner of preparations were made for his marriage, and the wedding-day was even fixed . . .
>
> At the last moment the alliance was broken off. Madame Doré seems to have had some hand in frustrating it. At any rate, as the day approached she grew more and more excited and unhappy. Doré could not help observing that the thought of his marriage seemed to prey upon his mother's spirits . . . She could not see him given up to another woman's care without feeling that her mission in this world was ended.
>
> The thought that any other human being could . . . take the first or indeed any place in his heart – racked her breast with jealousy. Yet she considered hers an unselfish affection![16]

Blanchard Jerrold, who knew Doré well, said that 'he would

<p align="center">69</p>

have married, had the fates been kind, an Englishwoman, he always said, because an English home-wife [sic] was his ideal of a woman, and home was the atmosphere in which he had lived all his life. He was admired by women; he was courted by them; he had tendresses, but his heart was never satisfied.'[17]

He was, perhaps, too independent, too self-willed and too set in his ways to make a woman happy. Perhaps he did not want to be fettered. In 1865 he recorded: 'I am neither husband nor father, member of the National Guard nor a Freemason.'[18] Yet Doré was very fond of children. Blanche Roosevelt observes that 'fond is not perhaps the word, for he adored them.'[19] For many years he used to spend New Year's Day at the foundling hospital, taking presents of clothing, money, and toys. He used to get up before dawn, 'and take carriage load after carriage load of presents to all the children's asylums in the neighbourhood.'[20] He distributed the toys himself, told the children fairy-tales, wound up their toy trains and spun their tops for them. In London he was often to visit the Hospital for Sick Children in Great Ormond Street, 'where he made many drawings of the pretty waifs both for himself and for them. Then he also went frequently to the Newport Refuge, to draw the little shoeblacks and picturesque-looking lads. He always made friends with all the children, they understood Doré at once.'[21] He himself was not to be a father; and when a friend once asked if it were true that he was engaged, Doré pointed to some unfinished paintings in his studio, and said, half sadly: 'No. My wives are there!'[22] His mother allowed no division of affection.

Edmond and Jules de Goncourt.
From a sketch by Gavanni

71

He was born in Strasbourg [wrote Jules Claretie in 1865]. I should have thought him a Parisian. He has the fire, the verve, the audacity, the brio, of a child of Paris. He paints, he draws, he chats, he comes and goes, he pauses, runs from one picture to another, laughs and romps about, then argues with you . . . Gustave Doré is very young, and yet it will soon be fifteen years since he *electrically* won his reputation . . .

Doré is small, slim, lively, elegant . . . He is thinking of illustrating Shakespeare, Ossian – and then? – the *Arabian Nights*, the *Niebelungen*. His ardour is wild; he embraces everything.[1]

The year 1865 saw Doré's illustrations to *The Epicurean*, by Thomas Moore. 'As for Gustave Doré,' wrote Édouard Thierry in his Preface, 'he is the great *metteur en scène*, he is the wonderful stage-designer – I won't say of the human comedy, but of the drama of fairytale and epic. He has done for *The Epicurean* what he did for *The Divine Comedy*, for Rabelais, for Cervantes . . . ; he has shown its main scenes on that enchanted stage which is his own.'[2]

It was no doubt Doré's love of drama, his abiding sense of theatre, which led him to illustrate the Bible. Alfred Mame, the publisher in Tours, was much concerned with religious books. On 10 September 1865 Anthony North Peat, the Government official and gossip writer, recorded that Doré was visiting Mame, 'whose magnificent edition of the Bible is to be illustrated by the creative fancy of his guest at the rate of no less a sum that 200,000 fr. (£8,000).'[3] The Bible, wrote Victor Fournel, satisfied both Doré's instinct for the grand and his continual yearning for a world in which he did not feel he was limited by pedestrian reality.[4]

Doré's Bible was published in London and Paris in 1866. Doré was Catholic, but he was not deeply religious. Yet the Bible was peculiarly suited to his powers. It offered him an almost endless series of intensely dramatic events. His visions of the looming Tower of Babel, the plague of darkness in Egypt, the death of

Samson, Isaiah's vision of the destruction of Babylon: these vast, forbidding scenes, heavy with doom, remind one of the visions of John Martin. They also reveal many elements by now familiar in Doré's work: the mountain scenes, the lurid skies, the complicated battles, the almost unremitting brutality. Doré's illustrations to the Old Testament remind us, above all, of the God of Wrath: of massacres and murders, decapitations and avenging angels. There is, too, a period element: the angels are Victorian angels, full of sentiment; the women are, again, keepsake women, the children are Victorian children: sentimental, or wise beyond their years. Yet despite these weaknesses, despite the wild complexity of some of the pictures, Doré still suggests the awesome majesty of the Old Testament: its patriarchal, epic quality.

His New Testament is notably gentle in comparison, and it is – perhaps for that reason – less inspired. None the less, his two hundred and twenty-eight illustrations to the Bible earned the admiration of his contemporaries; in France and abroad his Bible was his most popular work.

<p style="text-align:center">★ ★ ★</p>

Doré himself did not inspire moderate feelings. Some of his acquaintances found him engaging; others clearly found him repellent. On 18 August 1866, one of the Goncourts, on holiday at Trouville, watched

> the dancing dandies hopping about at the Casino. In the midst of them, a white waistcoat, a protuberant paunch . . . It is Doré dancing . . .
>
> After the quadrille, he leads his partner back, salutes her, . . . comes up to us, and asks us to take a stroll on the jetty. He throws off ideas, but without connection, without continuation. He makes statements, but as if for himself, in the depths of his throat, and inaudibly. He catches hold of you with a mass of questions, but he never listens to your answers. In the end, somehow or other, he dulls you, exhausts you, bores you to death.
>
> His very physique is wearisome and disagreeable. This

fat, fresh, chubby man, with the round flat face, a moon face, a magic lantern face; this man with his schoolboy's complexion, his ageless mien . . . It is all antipathetic, and in the end it makes me ill at ease.

He told me, to give me an idea of his work, that he missed one night out of three.[5]

The Goncourts might be antagonistic, malevolent and waspish; but the Emperor still enjoyed his company. In November, once again, Doré stayed at Compiègne. Among his fellow-guests was the American beauty and socialite, Mrs Moulton. In her memoirs she recalled the Imperial banquets, the Waldteufel waltzes, the visit to the château de Pierrefonds, which Viollet-le-Duc had long been restoring. She also recorded the charades which were organised by Prince Metternich. Pauline Metternich, she said, 'looked very comical dressed as a Parisian coachman, with a coachman's long coat of many capes; she wore top-boots, and had a whip in her hand and a pipe in her mouth, which she actually smoked.'[6] On 30 November, on her return from Compiègne, Mrs Moulton reported:

During breakfast yesterday the Emperor took up his glass, and, looking at me across the table, drank my health. Among the guests there was a great deal of health-drinking.

Gustave Doré had made some very clever caricatures of some events which he had drawn beautifully and touched off with aquarelle, as he alone could do it. The little album was passed stealthily from hand to hand under the shelter of the table, with the strictest injunctions not to let anyone see it except your *immediate* neighbour! With these injunctions it managed to travel about halfway down the table.

He had made a lovely sketch of her Majesty driving a chariot like the 'Aurora' in the Rospigliosi Gallery, and had depicted the Emperor seated on an enormous white horse, leading a charge of cavalry, his arm uplifted.

The Princess Metternich was represented as the coachman in the charade, hat on one side, pipe in her mouth, and

Napoleon III. From *La Vie parisienne*

74

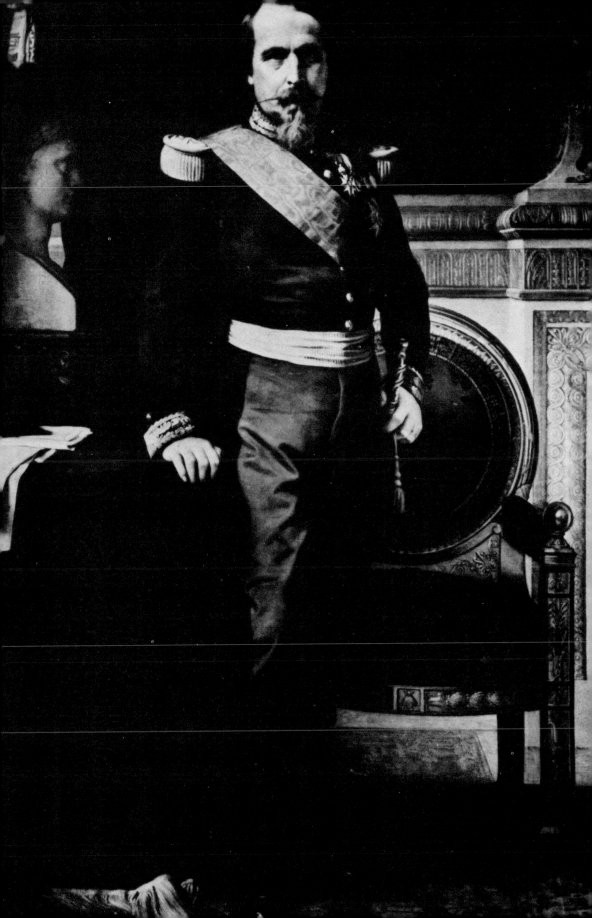

looking very *debonnaire*. Prince Metternich was shown standing in the middle of an arena, in full diplomatic uniform, with masses of decorations and *cordons*. He had a long whip, such as are used in circuses, and men and women (meaning us, I suppose) were capering around doing their tricks.[7]

Some time later, Doré presented a pen-and-ink sketch to the Empress for her *fête*. He offered the Emperor a copy of his *Purgatoire*. The Emperor gave him a pencil-holder with a diamond tip – which Doré gave away to a woman friend. The Empress begged him to go with her to the opening of the Suez Canal. Doré refused this imperial command to chronicle history. His explanation was incredible. 'Arthur [this to Arthur Kratz], they want me to go to Suez; but I shan't go. I should meet new people, a new race. These Oriental ideas and customs . . . might instil new thoughts into my mind, and upset all my present train of work . . . I am too old to attempt new departures in art.'[8]

<div align="center">

★ ★ ★

</div>

In 1866, Cassell, in London, had published Doré's *Paradise Lost*. One or two of the illustrations reiterate that Doré would have been a notable painter of murals, or a distinguished scene-designer. Yet sometimes, in this book, we feel that he was indeed afraid of new departures in art. Once again we recognise the influence of John Martin: his pictures of Biblical doom, his vast, bleak architecture, his storm light and his agonised victims. But Doré is a Victorian Martin, and his composition is too contrived; and if his first illustration in *Paradise Lost* immediately suggests Blake, it is, again, a Victorian Blake. The sense of original genius is absent. Blake has a spontaneity, an innocence, which convince us that his visions were dictated by inspiration. Doré suggests only virtuosity.

His virtuosity is often in evidence. His composition is often remarkable. His management of light and shade is sometimes brilliant. Yet there are many criticisms to be made. Doré all too often shows his ignorance of human anatomy. There are no bones or muscles in these legs and arms, the heads do not belong

to the bodies. All too often, Doré seems to plagiarise himself. There are too many cirrus clouds edged with lurid light; there are too many lowering crags, too many vast processions of fiends or angels. Doré's inspiration is markedly inadequate. He is playing with a limited number of formulae, and his lack of ideas is all too plain.

His contemporaries were well aware of his weaknesses.

> M. Doré has no time for study [wrote Jules Claretie]. M. Doré dates only from himself. M. Doré would willingly make a burnt sacrifice of Rembrandt and Rubens and the Flemish artists and the Italians, all people whom he considers to be useless.
>
> When he had to paint . . . that strange battle of Inkermann, black and red like a lobster which had only been half cooked, he was advised to visit the Crimea, to study the battlefield and nature on the spot.
>
> 'Nature?' he replied. 'What is nature?'[9]

He still disdained nature. No figure in a Doré battle could have stood up by itself. If you had removed it from the painting, all the other figures would have collapsed. As for Doré's landscapes, it was sometimes hard to accept them.

> The most ordinary mountains are as high as the highest peak in the Himalayas; his ravines seem to cut through the earth. His fortresses are so formidable that one pities the wretches who dare to attack them. But at the same time one wonders how anyone could have built them, since they are inaccessible.
>
> The public love Doré [added Lemercier de Neuville]. They love him because he makes them laugh, because he surprises them and touches them . . .
>
> That is enough for the public, and the public is right.
>
> Artists want something else besides, they want learning and art.[10]

8

However, the public loved Doré, and Doré continued to illustrate book after book. Early in 1867 Sampson Low, in London, published the English version of Victor Hugo's *Les Travailleurs de la mer*. It appeared under the title *Toilers of the Sea*. Doré drew two superb, starkly black-and-white illustrations especially for this translation. No-one was better fitted to show the celebrated struggle with the octopus, or Gilliatt on the wreck of the *Durandal*. Victor Hugo, in 'exile' in Guernsey, sent him pontifical praise.

> Young and mighty master,
> I thank you. This morning, through a tempest which was worthy of it, I received your magnificent translation of *Les Travailleurs de la mer*. You have put everything into this picture, the wreck, the ship, the reef, the hydra and the man. Your octopus is terrifying and your Gilliatt is grand . . .
> This splendid specimen of my book demands the rest. God, yourself and the publisher willing, that will certainly come to pass. [1]

Les Travailleurs de la mer was to be the only one of Victor Hugo's novels which Doré illustrated. He refused to illustrate *La Légende des siècles* because, he said, in poetry where everything was described, there would be no room for his imagination.

His imagination guided him; it was instantaneous and compulsive. Pressed for time, amazingly facile, sure of his technique, he rarely did preliminary sketches on paper. He drew direct on to the block (always the smoothest box-wood), did a summary colour-wash, and went on to the next picture. He sometimes had fifteen or twenty plates before him; he went from one to another with prodigious speed and dexterity, finished them all in a morning, and took them to the engraver. After *déjeuner*, he went the round of the engravers' workshops, before he returned to his painting.

'I illustrate just to pay for my paint and brushes.' So he main-

tained. He felt that painting was his true vocation. In 1866 he had moved his studio to a large gymnasium in the rue Bayard; he sometimes worked here for eighteen hours a day. Zola called him the only bearable illustrator of the age, but Doré felt that he was born a painter. He felt himself a misunderstood genius. In despair, he sometimes tried to compel attention by the sheer size of his canvases, the drama or topical interest of his subjects. In 1867 his chief exhibit at the Salon was *Le Tapis vert*: a picture of the gambling room at Baden. Many celebrated contemporaries were portrayed round the roulette table in this gigantic canvas, which was seventeen feet high and thirty-four feet wide. The Paris correspondent of the *Daily Telegraph* decided that 'Gustave Doré's great picture is a *fiasco* . . . The grouping is not good, the people are not natural, the idea altogether is wrong . . . The whole picture is entirely unworthy of Gustave Doré.'[2] (It was eventually sold to an American for £2,200).[3]

Felix Whitehurst's opinion was shared by other critics; and Doré recognised that his prospects were declining in France. Even as an illustrator of books, it sometimes seemed that he was failing. His pictures showed that his heart was not in his work. The same illustrations often recurred in different books; and the borrowings were not always acknowledged. Hetzel once complained that some lithographs printed by Lemercier under the rubric *Album Doré* had been taken from the *Contes de Perrault*. These borrowings did considerable harm to the sale of the book.

However, if there were problems in France, there were dazzling new opportunities on the other side of the Channel. Messrs Fairless and Beeforth of Bond Street had offered Doré a contract for a gallery where his work would be permanently on show. The Doré Gallery was opened in 1869. The exhibition was to continue, with additions and alterations, well into the twentieth century. Londoners had already seen Doré's paintings in the Egyptian Hall in Piccadilly, but the new gallery, at 35, New Bond Street (now Sotheby's), was on a greater scale. Even *Le Tapis vert*, which measured 578 square feet, could appear in New Bond Street to full advantage. There were smaller rooms for drawings and sketches. The Doré Gallery was the perfect answer for a man who could not stop producing pictures. Henceforward

The newspapers will continue more than ever, by accounts of sea serpents and
other monsters, to spread horror and consternation among their subscribers.
(*Two Hundred Sketches, Humorous and Grotesque*, 1867)

But they will likewise continue, in the morning, to contradict the horrifying
facts they have announced overnight.
(*Two Hundred Sketches, Humorous and Grotesque*, 1867)

England brought Gustave Doré most of his rewards; and the greater the rewards, the more the honours accorded him in England, the colder the French public became.

<p style="text-align:center">★ ★ ★</p>

Doré had begun to be famous in England during the mid 1850s. All his more important work as an illustrator, from the *Contes drôlatiques* onwards, was published in England as well as in France. Though Cassell published his Bible, he worked for any firms that would offer him suitable commissions.

Sampson Low had published his illustrations to *The Toilers of the Sea*. The same year, Frederick Warne reproduced *Two Hundred Sketches, Humorous and Grotesque*: a collection of the comic drawings which Doré had done for *Le Journal pour rire*. It was brilliantly alive. Doré made his engaging and original comments on vogues and enthusiasms in France. He showed Parisians busily concerned with aeronautics, alarmed and reassured by the Press (these last cartoons in a style which anticipates that of Pont). He found them enjoying the Champs-Élysées, experimenting with the latest coffee-machines. He re-called his own schooldays at the Lycée Charlemagne. He recorded his summer excursions in caricatures of Baden: the Prussian officers strutting in the Conversation Salons, the equestrian excursion, the tourists drinking at tables in the castle ruins. In these diverse and astonishing sketches, Doré confirmed that he was a master of the grotesque, the quietly and outrageously amusing.

He was also asked to illustrate Tennyson's *Idylls of the King*. This was published by Moxon in 1868. There was nothing grotesque in such a subject; there was everything to encourage sentimentality. The picture of Lancelot approaching the Castle of Astolat shows Doré's incisive use of black-and-white; for the rest, the illustrations merely show a world of keepsake damsels and effeminate knights, of familiar castles on brooding heights. Even the ruined castles suggest Alsace rather than Camelot. The broken Piranese spiral staircase is a remembrance of Strasbourg

A vision of Death. From Doré's Bible (1866)

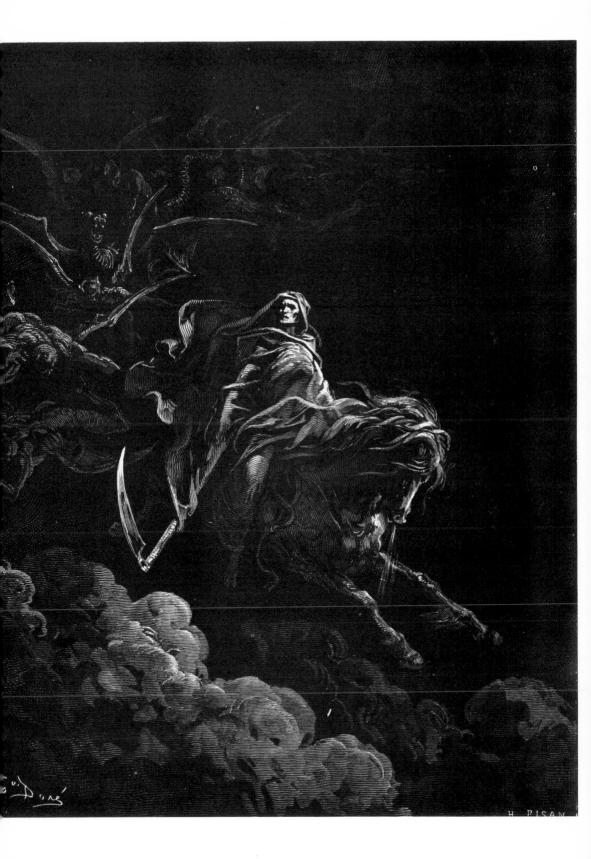

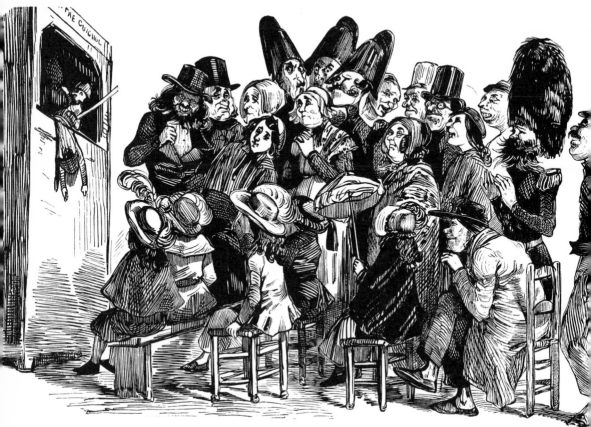

Theatre Guignol (*Two Hundred Sketches, Humorous and Grotesque*, 1867)

rather than a detail of Arthurian England. As *The Athenæum* observed of Doré's *Vivien* and *Guinevere*: 'These magnificent drawings . . . have only a loose connection with the *Idylls*. They have neither the scenery nor the sentiment of Mr Tennyson . . . We suspect, indeed, that M. Doré has never read Tennyson, and never thought of Tennyson while engaged upon this work.'[4] The Poet Laureate himself suspected as much. In the summer of 1869, he and Frederick Locker Lampson had breakfast with Doré at the Moulin Rouge. 'We were much pleased with the good Doré,' Locker Lampson noted. 'Although Tennyson had not been entirely satisfied with the publication of the folio edition of the *Idylls*, which Doré illustrated, the two met and parted with perfect cordiality.'[5]

9

Since the beginning of his career, Doré had had his English friends and colleagues. Henry Vizetelly, a founder of the *Illustrated News*, had employed him in the days of the Crimean War. Blanchard Jerrold had admired his dazzling short-hand sketches of Queen Victoria's visit to France, and until Doré's death he was to remain an affectionate friend. In Paris, during the International Exhibition of 1867, Doré had encountered an Englishman from a very different world: the Reverend Frederick Kill Harford, sometime Minor Canon of Westminster. Harford was born to be an artist, and if his father had not mistakenly urged him to take orders, he would have found proper scope for his talents. Doré's acquaintance with Harford soon became a cordial friendship. In the studio in the rue Bayard they began discussing Shakespeare; and Doré was to owe Harford much of his success in English society.

On 18 May 1868 Doré arrived in London for the first time. He settled at the Grosvenor Hotel, Victoria Station, and his visit lasted over a month. Harford took him under his wing. Doré, as Blanchard Jerrold wrote,

> checked his gamineries, selected his friends with discretion, and, which was most important, was led into that serene atmosphere where he found higher and purer inspiration than he had felt before. His thoughts took a serious turn. A new world opened upon him. He came into contact with Mr Gladstone, Dean Stanley, Dr Tait, the late Archbishop of Canterbury, and other elevated minds.
>
> It was, in short, owing to the serious and cultivated society that was opened up to him in London, that Doré's mind took a new direction, . . . and that he buckled on his armour to do mightier work than he had yet achieved.[1]

Doré's visit to England made him new friends, and helped to consolidate his reputation. It also filled his mind with new scenes, and gave him a new world to explore. He was sought out, recorded Blanche Roosevelt,

presented here and there, taken to balls, theatres, and 'at homes;' put up at clubs, dined, wined, and fêted; carried off to horse-races and boat-races, to cricket and polo matches, to dinners at Greenwich and Richmond; he lounged in the Row and lunched in the Mall; kettledrummed at five and dined at eight, while it was yet daylight. He basked in the smiles of fair women and great ladies, in princes' favours and prime minister's civilities. Rich, gifted and engaging, preceded by his brilliant reputation, he was lionized and talked about; in short, to sum it all up, he was 'the fashion.'[2]

During his stay in England, he went to visit Canon Harford's father in Gloucestershire. Henceforward English country life had a special charm for him. His publisher, Thomas Dixon Galpin (of Cassell, Petter & Galpin), lived at Datchet, near Windsor, and Doré often went to visit him. The countryside gave him 'a glimpse of an earthly paradise. His admiration of Windsor and the surrounding scenery was absolutely without limit.'[3] As Doré and Jerrold were driving through Windsor Great Park, Jerrold observed that,

> though the eye of the artist ceaselessly ranged over the landscape, in which he took great delight, no notes or sketches were made. A lady asked whether he would not stop, and jot down a few pictorial memoranda. 'No, no,' he replied. 'I've a fair quantity of collodion in my head.' In other words, he could carry away with him a mental photograph of what he had seen.[4]

Jerrold, too, had a quantity of collodion in his head. It was he who now drew Doré's portrait.

> He has the boyish brightness of face which is so often found to be the glowing mark of genius. The quick and subtly-searching eye; the proud, handsome lip; the upward throw of the massive head; and the atmosphere encompassing all – an atmosphere that vibrates abnormally –

The Ladies' Mile (*London – a Pilgrimage*, 1872)

proclaim an uncommon presence. The value of his work apart, he is a remarkable figure of his time.[5]

Remarkable indeed. In this autumn of 1868, Jerrold encountered him again, at an Embassy ball in Paris. Doré left just before three o'clock in the morning. 'I must to bed,' he explained. 'Three hours are barely enough for a worker.'[6]

<div align="center">★ ★ ★</div>

On 29 February, Doré had attended the dinner-party held to mark the seventy-sixth birthday of Rossini. Ten guests had dined with 'the Swan of Pesaro' and Olympe Rossini. The table had been adorned by a birthday cake sent by the Baronne de Rothschild. It was also enlivened by a confection in which a swan with outspread wings held garlands bearing the names of Rossini's chief compositions. Doré had given Olympe a fan that he had painted.[7]

But Rossini's health was failing, and his guests had been aware that this birthday might be his last. On 26 September he held his last *samedi soir*. Gustave and Ernest Doré were among those about him in the final days of his life.[8] Rossini died on 12 November. Next morning, Doré made two sketches of 'the Swan of Pesaro' on his deathbed. He later based an etching and a painting on one of them. The etching shows a bewigged Rossini, his head deep in a bolster, his peaceful face suggesting the familiar portraits of Dante. At the time of Rossini's funeral, 'several members of the deputation from Pesaro called on M. Doré to view this interesting souvenir . . . So affected were they by this splendid sketch . . . that they were melted to tears.'[9]

<div align="center">★ ★ ★</div>

Doré opened the new year, 1869, with a splendid entertainment for

> a large circle of distinguished personages. Among those present [wrote North Peat] was Mr W. Gladstone, cousin of the Premier . . . Were I to give the names of those who

Rossini on his deathbed, 1868. From a drawing by Doré

crowded Doré's *salons*, . . . I should simply recapitulate the best-known names in Paris Society. Louis Engel performed his delicious fantasia of Irish airs on the organ; Saint-Saëns – Rubinstein's rival, as you are aware – executed on the piano, that most intricate of Beethoven's compositions, the *Valse des Derviches*, with the rare musical science and exquisite sentiment which have won for him so great a reputation.[10]

The rue Saint-Dominique was renowned in the world of music. Saint-Saëns himself recalled 'the great pale face [of Liszt] at Gustave Doré's, letting his spellbinding glance wander over his audience . . . One will never see again, one will never hear again, anything like it.'[11]

Another superb performer was heard in the Doré *salon*: the violinist Pablo de Sarasate y Navascues.

My dear Sarasate [Doré wrote one Sunday morning],

I learned only yesterday evening from Diemer [the pianist] that you had come back from Chartres; I therefore hasten to send you my thanks for your letter, and to tell you how glad we shall be to have you. Diemer has promised me he will come that evening. In fact I am waiting for the grand piano, which should be sent this morning.

Enclosed is the drawing which you asked me for. As I have literally nothing on paper, I am sending you a block from my illustrations to the Bible.

Yours ever,

GUSTAVE DORÉ[12]

One entertainment followed another in the rue Saint-Dominique. On 27 February *La Vie parisienne* recorded that

last Sunday there was a delightful gathering at Gustave Doré's. At first sight there is nothing stranger than this studio-salon, with its vaults painted like those of a chapel. On the walls, on easels, everywhere, there are landscapes of the Black Forest, ruined burgs, deserted lakes, colonnades of pines, gigantic canvases which make holes in the walls

and seem like windows open on to the banks of the Rhine. A big grand piano, an organ, various musical instruments, anyone who wants to may play them . . . If we were not afraid of crossing the wall of private life we should give you the name of a wonderful lady, a brown Brazilian, who sang the *O Salutaris* from the new mass by Rossini. All our compliments to her and to the simple and excellent Nadaud, who . . . held us, listening, until two o'clock in the morning.[13]

* * *

At times even Doré found it hard to combine this social life with his incessant professional commitments. He was more and more solicited by publishers, he was increasingly overwhelmed by work. He often excused himself for not having finished – or even begun – a drawing which he had promised. To him, his illustrations remained of secondary importance. He was preparing his work for the Salon; he also had to cover the walls of the Doré Gallery in London. He was still compelled to bear the slings and arrows of the critics. On 1 May, discussing the exhibition in Bond Street, *The Athenæum* decided that

real sentiment is nowhere here. One seems to see the showy actor making believe on every canvas. It is needless to name all the crude and vainglorious *tours de force* on these walls . . . As to the much bepraised *post-mortem* portrait of Rossini, we confess to sickening at it. One does not slap one's breast over the body of one's dead friend, then paint his likeness, and show it for a shilling.[14]

* * *

Doré received more generous appreciation from the English critic Amelia Edwards. A popular novelist, a *femme de lettres*, an eager traveller, one day to paint her impressions of Egypt, Miss Edwards was to remain a stalwart friend. Doré's first surviving letter to her was written on 10 May 1869. It already suggests his warm regard for her.

Dear Mademoiselle,

I want to thank you for your great kindness in telling your readers about the new works which I am showing in London. I also want to express my warmest gratitude for the kind and flattering lines which you devote to me, and the constant kindness of which you give me yet another proof. It is indeed time, dear Mademoiselle, to come to London (which I hope to do soon) and to express all my gratitude in person . . .

Thank you, dear Mademoiselle, for dwelling on the likeness of my dear and lamented maëstro Rossini. A feeling of piety dictated the painting to me, and it is a very great favourite of mine . . .

Thank you again a thousand times, dear Mademoiselle, and I hope to see you soon; for I really think that before the end of the month I shall pay a brief visit to London and have the pleasure of shaking hands with you – which will happen, believe me, on the very first evening.[15]

<p style="text-align:center">★ ★ ★</p>

Two works, it seems, were inspired by Doré's second visit to London. The first was suggested by Blanchard Jerrold, when Doré was staying with him in Jermyn Street. Jerrold, a man of letters and a practised journalist, suggested that he might write a book on London, and that Doré might illustrate it. 'The plan was unfolded one morning, while Doré was smoking, and dreamily covering paper with sketches. It gradually engrossed him.'[16]

Doré's *London* was to be among his most popular works; but this visit of 1869 was to inspire more than a book: it was to inspire a new dimension of his art. One day, he and Canon Harford were on their way to Sydenham, to dine with the remarkable George Grove. Born in 1820, Grove was one of those Victorians who astonish a later age by their energetic, versatile achievement. As a civil engineer, he had built lighthouses in the West Indies. He had since been secretary to the Society of Arts and to the Crystal Palace, where he had supplied the most important series of annotated concert programmes ever issued in this country. He was also a Biblical scholar, and he helped to edit Smith's

Dictionary of the Bible and to found the Palestine Exploration Fund. He wrote articles and books on diverse subjects, including a *Primer of Geography*. For fifteen years he was editor of *Macmillan's Magazine*. In 1879–89 he was to publish his celebrated *Dictionary of Music and Musicians*. In 1883 he was to be knighted, and to become the first Director of the Royal College of Music.

It was on their way to dine with this eminent Victorian that Doré and Canon Harford began to discuss religion.

Doré said he was hardly an orthodox Christian, a member of a church, a man with his faith pinned to any ritual. He was led to make this remark by an observation of his friend, that there were high and grand paths of his art on which he had not yet ventured – there were Biblical themes which should fire his genius – he had yet to give to the world the sublimest emanations of his power.

Doré gazed dreamily, as his wont was when an idea struck him with force; and then, turning earnestly towards the Canon, he said that his religion lay folded within one chapter of the Sacred Writings. He then began:

'Though I speak with the tongues of men and of angels, and have not charity, I am become as sounding brass, or a tinkling cymbal . . .'

And so he went on, not omitting a word, to the thirteenth verse. It was, he said, his creed. A man must be a good man to his fellows in thought and in deed . . .

After dinner, at Mr Grove's table, and over a cigar upon the lawn, the subject broached in the train was resumed; and Mr Harford drew Doré's attention to a passage in the life of the Saviour which had not, so far as he knew, been treated by a master's hand. It was the moment after judgment when Christ came forth from the Praetorium, and before He had taken up the Cross.[17]

The first of Doré's sacred subjects originated in George Grove's garden at Sydenham. *Christ leaving the Prætorium* was not to be completed until 1872. Doré considered this picture to be his supreme achievement.

III

'A vehement unresting mind'

1870–1881

IO

On 15 July 1870, France declared war on Prussia. The Franco-Prussian War was fought – nominally, at least – over the Hohenzollern candidature for the vacant throne of Spain. Prussia had already agreed not to press her candidate; but France was determined to make amends for the Prussian defeat of Austria at Sadowa, she was determined to contest Prussian military supremacy, the threat of a German confederation. Bellicose and unprepared, she entered the most disastrous war in her long history.

Some considered Doré to be the most German of French artists. Whatever his artistic inspiration, he was, as Blanchard Jerrold said, 'a Frenchman to the backbone in sentiment and in love of country.'[1] When hostilities began, he drew his impression of the French army crossing the Rhine. He was sure that this was how the struggle would go. To him the loss of Strasbourg was a tragic surprise. He had hoped to end his days there when his work was done; now he knew that he would not return there. He expressed his sense of bereavement in a cartoon, *Alsatia*. The chief figure was a mourning peasant woman, with the tricolour clasped to her breast. This and other patriotic cartoons were published, and widely sold.

On 2 September, six weeks after hostilities began, Napoleon III surrendered, with his army, at Sedan. On 4 September the fall of the Empire and of the Bonaparte dynasty was decreed, and the republic was proclaimed. But the war with Prussia went on. The enemy closed round Paris, and the Siege began. As it continued, Parisians suffered not only from isolation and bombardment, but from the rigours of winter, and the increasing scarcity of provisions. Domestic pets and even the animals in the Jardin des Plantes had to be eaten. Chevet, who had once invented delectable dishes for dinner-parties in the rue Saint-Dominique, now displayed a pound of butter as the centrepiece in their window. Doré was generous to those who could not afford to buy food. He often took provisions to his friends.

I wasn't mobilised, that is to say, a soldier, for the operations outside, as the age rule did not touch me [he later

Street barricades in the rue Royale, 1870–71. The Madeleine may be seen in the background

told Amelia Edwards]; I only served in the Garde nationale of Paris and its fortifications. I never had any glorious wounds, except a few wretched colds and some pains and stiffness in the joints.

Although I stayed in Paris, dear Mademoiselle, I saw enough dramas and ruins to give you some very long descriptions.[2]

He made many drawings of the Siege, but he refused to show them in London. 'Not for the world!' he exclaimed to Miss Edwards. 'Would you have me exhibit the misfortunes of my country?'[3]

Late in January 1871 the Siege of Paris ended. The city had capitulated to starvation rather than the Prussians. Amelia Edwards wrote to him at once.

Dear Mademoiselle [he answered],

. . . In spite of the many sufferings, fatigues, privations of every kind, and especially of a diet so strict that, towards the end, many people found it fatal, I have emerged safe and sound from this ordeal . . .

French troops camping in the Tuileries Gardens during the Franco-Prussian War, 1870–71

I hope I shall soon have occasion [to meet you]. I like to think, Mademoiselle, that you'll spend a few days of the Season in London. I hope to have details of this from our mutual friends, so that I don't miss this pleasure.[4]

In March, incensed by Thiers' capitulation to the Prussians, the Communards seized control of Paris, and the Government, then sitting at Versailles, was obliged to begin a second and more bitter siege of the city. The Commune was, to Doré, the worst tragedy of all. He and his mother took refuge in Versailles with an old friend, Mme Bruyère. He followed the sessions of the Assemblée, noted the pretentious solemnity, the idiotic stupidity of its members; he watched the processions of Communard prisoners as they arrived from Paris.

In the evening, among his friends [remembered Mme Bruyère], to the repeated sound of the cannon at Mont-

Valérien and the heights of Montretout, thundering
incessantly against Paris; at the striking memory of those
long processions of Communard prisoners brought back
from Paris to the avenues of Versailles, at the sight of those
wretches, their brutish faces contracted with hatred, rage,
and the suffering of a long march, under a burning sun, he
took pleasure . . . in making these sketches.[5]

The sketches in question were his deft, spontaneous cartoon of
Adolphe Thiers, and his brutal impressions of the Assemblée
nationale. These were followed by a series of Communard
portraits: savage sketches of inferior, brutish, sometimes
subnormal humanity. Doré gave his album to Mme Bruyère; it
was not published until 1907.

<div align="center">★ ★ ★</div>

The Commune was overthrown on 28 May 1871, and Doré and
his mother returned to Paris. The war and civil war were over,
but a world had ended. Offenbach was well aware that many
people associated his music closely with the Second Empire.
When Doré chanced to meet him, and went up to shake his hand:
'What!' cried Offenbach, 'aren't you afraid of compromising
yourself?'[6]

Jerrold visited Doré in Paris, 'and saw, in the morning we
spent together, that a cloud had settled upon him. The old
laughter hardly bubbled, even in many walks. The boy had gone
out of the man . . . He was soured as well as grieved; and he used
to say that if it were not for his Bond Street Gallery, where his
work was generally appreciated, and for the projects he had to
realize, he should give way.'[7] Four of his dogs were rolling at his
feet. Jerrold asked: 'Where are the pugs?' 'They ate five for me,'
was the reply.[8] Such had been the rigours of the Siege.

Round the rue Saint-Dominique, many houses were in ruins.
Jerrold noted that Doré 'could smell the smouldering ashes of
the Palais d'Orsay from his bedroom window; he could see the
ruins of the Tuileries directly he turned into the Champs-
Élysées from the Rue Bayard. To pass from his work to his club
(the Mirlitons) in the place Vendôme, he had to skirt the charred

Pour Dieu, Messieurs, pas d'ambiguité !...
De deux choses l'une : ou la France sortira de cette
crise fatale et alors ce sera son salut ; ou elle
y succombera et touchera jusqu'au fond de l'abîme —
— alors ce sera sa chute

A member of the Versailles Government. One of Doré's savage cartoons in *Versailles et Paris, 1871*

shell of the Ministry of Finance, and to step over the broken masses of the Vendôme Column. He had learned to abhor the devastation and the horrors of war.'[9] Jerrold's comments were confirmed by Doré himself. On 13 June he reported to Amelia Edwards:

> In spite of the unceasing anguish, the threats of every kind, and the imminence of the fire which burnt down houses very near our own, we are safe. As for our property in the rue St Dominique, it is all right except for a few scratches and a few pieces of furniture thrown into the street to make a barricade beside the house. My elder brother . . .

Adolphe Thiers, head of the Executive and future President of the Republic. From a sketch by Doré in *Versailles et Paris, 1871*

is less fortunate. He had the whole first floor of his house blown in by shells from the Asnières battery, and the contents of two rooms were smashed to smithereens.

We shall bear the burden of all these sorrows and ruins for a long while, dear Mademoiselle. To-day there is no Frenchman who has not been touched, if not by bereavement, at least by disaster and destruction, not to mention certain political hatreds which take a long time to die out and add still more to the bitterness of the situation. As for poor Paris, I no longer dare to look at it. It has irrevocably lost its ornament, its crown, and its precedence as an elegant metropolis; and they say that the vast city might

A vista of ruins. Paris after the siege and the Commune, 1871

well have been reduced to a heap of stones, for those monsters without name had decreed a general conflagration.[10]

<center>★ ★ ★</center>

According to Blanchard Jerrold, Doré arrived in London on 10 July, and he settled at Morley's Hotel.[11] According to Blanche Roosevelt, he came with the draughtsman Bourdelin, who was to help him 'in the architectural and picturesque portions' of his work on London.[12] Bourdelin's account of events is different in many points from Jerrold's, and it should be taken with some caution. 'We went to London and passed nearly six months there together,' Bourdelin wrote.[13] This would mean that they stayed in London until the new year.

> Doré inhabited a superb apartment on the first floor of the Westminster Palace Hotel [Bourdelin continued]. One room had been transformed into a studio, and there we worked during the whole summer of 1871 [*sic*]. For our trips round and about London in search of material for our

sketches and studies of character from the life, two private detectives had been placed at our disposal; and every night we spent hours in such populous districts as Lambeth, Clerkenwell, Bayswater, and the Docks.

It was a real pleasure to watch Doré, dressed in some ragamuffin style or other, hurrying in and out of the streets and alleys, and rapidly taking notes with the rarest precision – notes which served him for the composition of his blocks. I filled in backgrounds, houses or monuments, which he afterwards animated with his glowing fanciful pencil.[14]

Jerrold also left an account of his own explorations with Doré; the mention of the Boat Race makes it difficult to date: perhaps it refers to a visit in the spring of 1869, perhaps it means that, after Bourdelin had gone, Doré remained in London into the late spring of 1872.

We spent many days and nights [wrote Jerrold] visiting and carefully examining the more striking scenes and phases of London life. We had one or two nights in White-chapel, duly attended by police in plain clothes; we explored the docks; we visited the night refuges; we journeyed up and down the river; we traversed West-minster, and had a morning or two in Drury Lane; we saw the sun rise over Billingsgate, and were betimes at the opening of Covent Garden market; we spent a morning in Newgate; we attended the boat-race, and went in a *char-a-banc* to the Derby . . . ; we dined with the Oxford and Cambridge crews; we spent an afternoon at one of the Primate's gatherings at Lambeth Palace; we entered thieves' public-houses; in short, I led Doré through the shadows and the sunlight of the great world of London. His constant remark was that London was not ugly; that there were grand and solemn scenes by the score in it . . . We went, once, at midnight, to London Bridge, and remained there an hour, while he meditated over the two wonderful views – that above, and that below bridge. His heart was touched by some forlorn creatures huddled together, asleep, on the

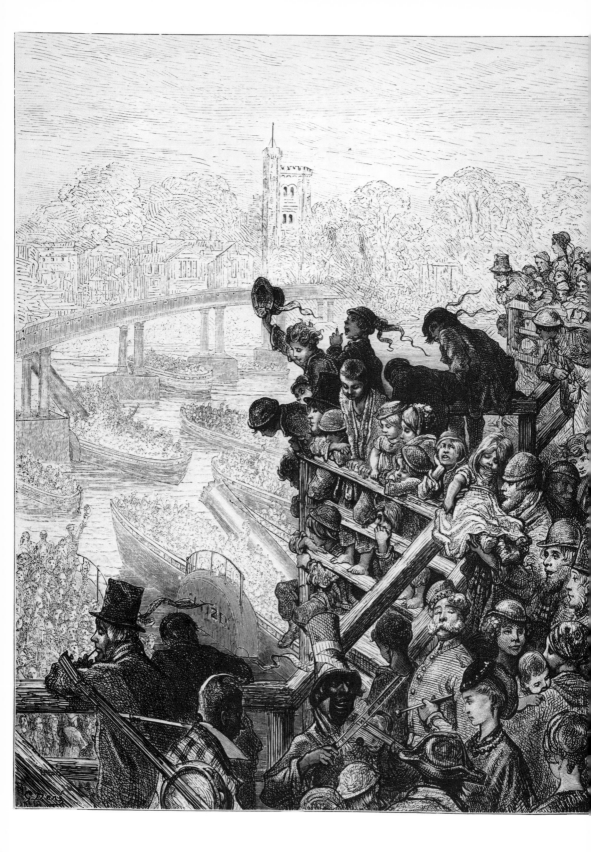

stone seats. He has reproduced it, again and again . . . He never appeared to tire of it.[15]

For all his intense activity, Doré was still in a state of profound dejection, and his friends found it difficult to cheer him.

His sensitiveness was now morbid [wrote Jerrold]. A feeling of resentment against his French critics appeared to have become fixed in his mind. When I met him at breakfast in the morning, at his hotel, he would indulge in a burst of anger and regret that he had undertaken to illustrate *London*. He feared that the illustrator would be again welcomed at the expense of the painter. This dread remained with him whenever he took up his pencil.[16]

Jerrold urged him to submit some paintings for the Royal Academy exhibition; but Doré would not do so, for fear of being rejected.[17] He and Jerrold usually began their day at the Doré Gallery. Doré never tired of it; to him it had become his only consolation as a painter.[18]

According to Bourdelin, there were other consolations. The Prince of Wales had more than once visited Doré in the rue Bayard.

In London, whilst we were working together at the Westminster Palace Hotel, the Prince came several times incognito, accompanied by his aide-de-camp, Colonel Teesdale. One day his visit bore a more official character. Princess Louise accompanied her brother, several ladies and gentlemen of the Court and of the Princess's suite came, having the previous evening announced the visit of His Royal Highness.

Doré resolved to receive them right royally. Loads of lovely flowers came in from Covent Garden Market, lavishly decorating his apartment, the staircase and vestibule of the hotel, and a magnificent lunch was prepared. About three o'clock, when three carriages (each drawn by four horses)

The Boat Race – a scene at Putney Bridge (*London – a Pilgrimage*, 1872)

were drawn up in front of the door, more than ten thousand people had collected in the street outside the hotel, and not the least frequent of their cries was: 'Hurrah for Doré!'[19]

It seems, to say the least, unlikely for a London crowd.

<p style="text-align:center">★ ★ ★</p>

On 30 August, while Doré was still in England, Théophile Gautier recorded his private visit to the rue Bayard.

> On easels, set in the most favourable light, along the wall, . . . in every corner of the enormous room, there were canvases in various stages of progress, and their subjects seemed to form the epic and picturesque cycle of the first siege . . .
>
> One of the drawings went back to the beginning of the siege . . . Enormous flocks of animals were hastening towards the city. They recalled . . . the migrations of the nations before some plague sent by the wrath of God.
>
> These flocks were to serve to feed the capital . . . Gustave Doré's imagination was deeply impressed by this curious sight . . . He has shown us this mass of humped backs and curved horns . . . being engulfed in the paths of the Bois de Boulogne, like an irresistible flood . . .
>
> Another drawing unfolds the panorama of Paris seen, far below, from the plateau of the Butte Montmartre . . . The enormous city is bathed in smoke, pricked with points of light . . . It seems like one of those Ninevehs or Babylons which the prophet glimpses in his dream . . .
>
> One composition has remained almost in the state of a sketch, but it held us for a long time in contemplation. The scene represents the return of an ambulance after a battle outside the walls . . . A haggard, wild-eyed woman, erect as a spectre, with that fixity in her eyes which heralds madness, is holding a lantern to the faces of the wounded . . . She is seeking a husband or a son who is doubtless numbered among the dead, and with every carriage she tirelessly begins her search again.

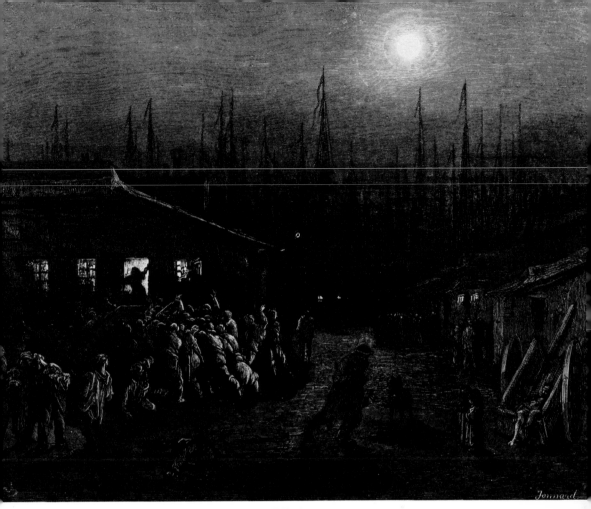

The Docks – night scene (*London – a Pilgrimage*, 1872)

It is not only the episodic and picturesque side of the siege which Gustave Doré has chosen to reproduce. He has drawn the works of the defence, the installation of the forts, the armament of the bastions, in a way that would satisfy engineers and artists . . . In this series of studies, sketches and compositions, . . . Gustave Doré has proved that art was irrepressible, and that no power could restrain its expansion.[20]

★ ★ ★

Doré returned from London to Paris. The receptions were resumed in the rue Saint-Dominique, but they were restricted to

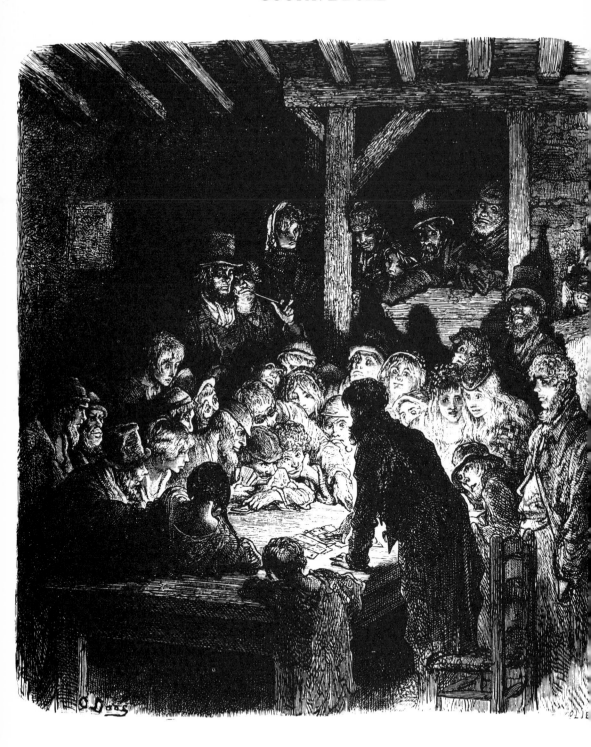

his family, and to his inner circle of friends. Ernest Doré's daughter, one day to marry Dr Joseph Michel, now joined in the family gatherings. But Doré saw that his mother was ageing; he was also growing conscious of his own physical decline. He had lived very hard, and he had worked unremittingly for the past twenty years. He constantly complained that he was tired.

He worked on, none the less. At times he worked defiantly, regardless of financial cost or of financial gain. He worked with desperate singleness of purpose, determined only to win recognition in the *genre* he felt to be his own. A visitor observed that

> a picture like that of *L'Entrée de Jésus à Jérusalem* demands for canvas, colours, models and accessories, a total expenditure of 50,000 francs; and, by its very dimension, it has very little chance of being bought. However, Gustave Doré did not hesitate for a moment to undertake this fabulous work . . .
>
> One day I was looking at the canvases hung up in the studio, and I asked Gustave Doré which was his favourite.
>
> 'This,' he replied, pointing out a canvas which was still untouched. 'One always prefers to the finished work the work which one is going to undertake, the work which still has the beauty of the dream . . . One always hopes that to-morrow's work will be better than yesterday's . . . It is certainly the best picture because it contains all possible pictures.'[21]

'The policeman's bull's-eye turned on extraordinary faces and figures.' Thieves gambling (*London – a Pilgrimage*, 1872)

II

There remained the painting which Doré considered his most important work: *Christ Leaving the Prætorium*. He had begun it in 1869; on the outbreak of the Franco–Prussian War his manservant, Jean, had buried it out of reach of Prussian shellfire. After the Commune, it had been returned to the rue Bayard; and in April 1872 *le tout Paris* was invited to come and see the finished picture, which Doré was about to send to his gallery in London.

The Salon of 1872 only confirmed that French critics would not accept him as a serious painter. Jules Claretie declared: 'I like M. Gustave Doré's talent too much to lay stress on his last two paintings, *L'Alsace* and *Le Massacre des Innocents*. Those are two errors, one of which is capital.'[1] English critics were less harsh; and the English public paid handsomely for his pictures. He had sold *Le Prêtoire* for 150,000 francs, and *Les Martyrs* for 100,000 francs. In 1870 the Queen herself had bought *Le Psaltérion* for Windsor. 'I cannot express,' wrote Doré, 'the proud pleasure that this has given me.'[2]

<p style="text-align:center">★ ★ ★</p>

Late in July 1872, Doré finished his London drawings and, once again, he crossed the Channel. His visits to London had left their mark on him; perhaps they emphasised the element of fantasy in his art, just as they had led him towards religious painting. As for the English language, he spoke it 'with *a true French intrepidity.*' He always intended to study it in earnest. But, writing to Amelia Edwards in 1879, he predicted that he would only speak fluently 'in twenty-five years' time, that is to say when I die.'[3]

None the less, Doré delighted in his annual visits to London during the Season; and, said Jerrold,

> he was charmed by the welcome he received in society. The Prince and Princess of Wales invited him to Chiswick, and received him at a *dîner intime . . .* Princess Louise delighted him by accepting one of his sketches. Lady

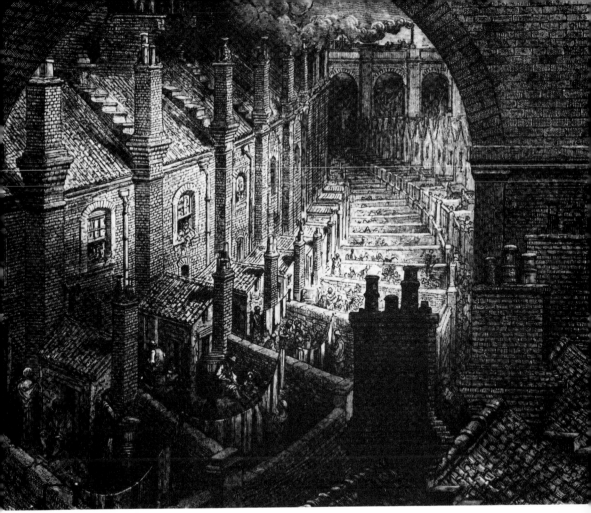

Illustration from *London – a Pilgrimage* (1872)

Combermere gave a dinner in his honour. Archbishop Tait
held a grand banquet in the Guard Room of Lambeth Palace,
at which he was the principal guest. When he was the guest
of the Lord Mayor, the ladies stood upon their chairs to look
at him and wave their handkerchiefs. He was a great attrac-
tion at fashionable charity fairs, to which he contributed
drawings liberally. He went to stay with the Orleans family
when they resided at Twickenham. His love of music drew
him to Lady Downshire's entourage. His friend, Canon F.
K. Harford (himself an accomplished artist), escorted him
to Lambeth Palace and to Dean Stanley . . . Sometimes he
would stay for five or six weeks, drawing and painting, first
in Jermyn Street, then at Morley's Hotel, then at the West-

minster Palace, and lastly at the Bath; and giving his afternoons and evenings to drives, calls, dinners, and receptions.[4]

In the summer of 1872 Doré and Jerrold finally wound up their London work. *London: a Pilgrimage* was published in December. Printed on thick creamy paper, adorned with one hundred and eighty illustrations, the volume weighed a stone.[5] It was, said *The Athenæum,*

> exactly what one might have predicted from M. Doré and Mr Jerrold. When we say that the illustrations put us in mind of everything which M. Doré has done before, excepting those of his works which were worthy of admiration and unhackneyed, the reader may believe that not only are these sketches utterly unlike London as it appears to English eyes, but that they afford another painful proof of how a great genius has been wasted . . . Whatever a light and 'jaunty' pen could do, without trouble to its owner or any study on his part, Mr Blanchard Jerrold has done in the text before us.[6]

The text of *London: a Pilgrimage* is pompous, contrived and turgid. Jerrold gives an impression of a metropolis where there seems a vacuum between extremes. This is a narrative about Society and the working class, about the indolent and the industrious, the privileged and the under-privileged. There is little about the middle classes, little about the cultural world. As a source-book on Victorian London, the text is crude and unrepresentative.

Victor Fournel maintained, from the other side of the Channel, that 'Doré completely understands the English character.'[7] But Doré, like Jerrold, is largely concerned with the dream world of the aristocracy, the splendour of Rotten Row, the lazy garden-parties at Chiswick, the croquet-parties, the evenings at Covent Garden. The figures which he draws are formulae rather than individuals. There is a Victorian, Anglo-

At lunch – a scene at Epsom Derby (*London – a Pilgrimage,* 1872)

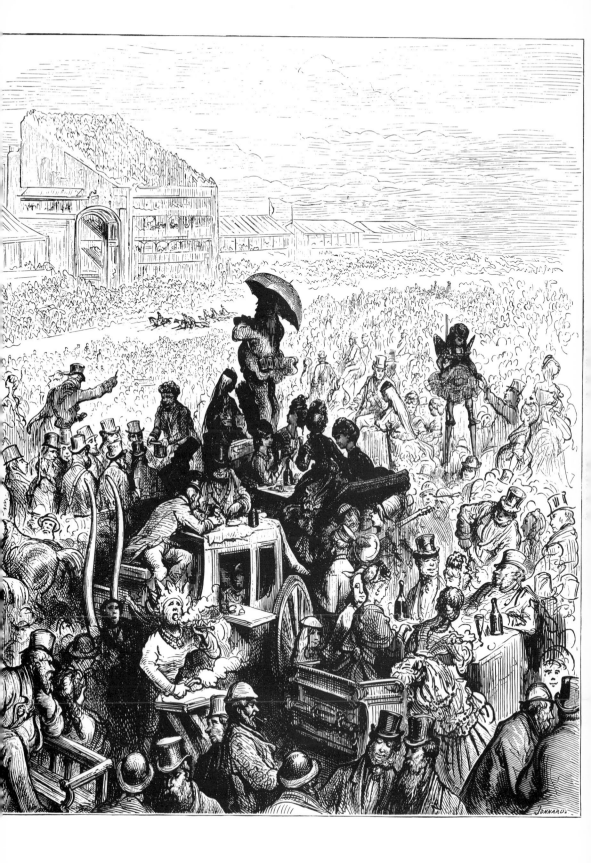

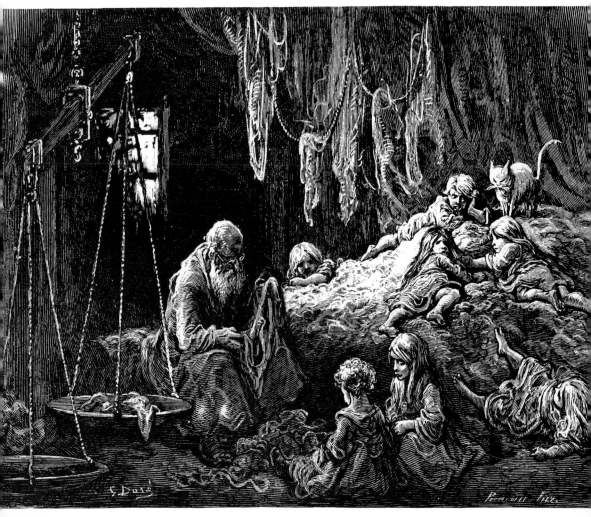

'The old clothesman's children were rolling about upon this greasy treasure, while he, with his heavy silver spectacles poised upon his hooked nose, takes up each item, and estimates it to a farthing'. (*London – a Pilgrimage*, 1872)

Saxon face which Doré repeats *ad nauseam*. His aristocrats are solemn and equine. His aristocratic women are fashion-plate creatures. His working-class women and children are Dickensian ciphers.

But a world divides this London from the London of Dickens;

and it is precisely because Doré's *London* is not seen through English eyes that it has its peculiar charm and uncommon power. Doré had a foreign freshness of vision; and some of his more general impressions reach an almost symbolic intensity. Doré's *London* is not a solid, all-embracing documentary. There are Norman arches in his London Bridge, and fifty horses racing in his Derby. His *London* is an almost Impressionist series of pictures. Some of them inspired Van Gogh; they still make a strong, if biased, comment on Victorian society. Some of them offer a nostalgic dream to the Londoner of the twentieth century.

* * *

Doré had not been the easiest partner in the London enterprise. Perhaps he still resented the time it had taken from his painting. Perhaps he resented the collaboration. Jerrold ignored his sullen mood when the book was finished. 'I knew it would pass,' he wrote, 'and I waited.'[8] But even Jerrold was moved to anger when he later found Doré's illustrations in a book on London by Louis Enault. Jerrold rightly protested at this 'unhandsome action'. It parted him from Doré for a year. Doré was the first to seek a reconciliation;[9] but Jerrold must have had an uncommonly forgiving nature.

* * *

In the first days of April 1873, Doré travelled by steamer from London to Aberdeen with his friend Colonel Christopher Teesdale. The Colonel had been introduced to Doré by Canon Harford. He had won the Victoria Cross in the Crimea, and he was an equerry to the Prince of Wales. He and Doré had become fast friends; he had now asked Doré to come salmon-fishing.

Doré was to grow almost as fond of the Highlands as he was of his native mountains.

I wish I had your fine style, dear Mademoiselle [he wrote, once again, to Amelia Edwards], to say how impressed and enthusiastic I have become . . . I think that henceforward, when I do *landscapes*, five out of six will be memories of

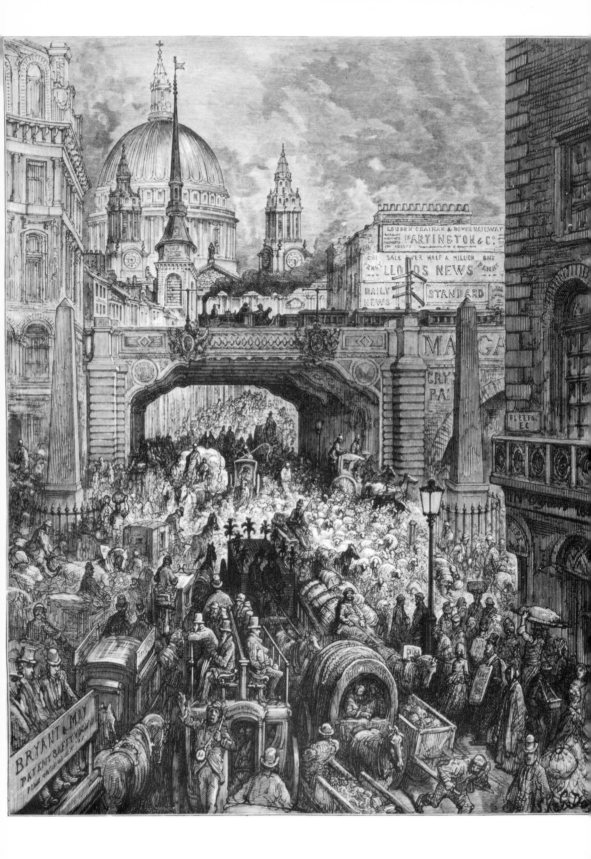

that country; and then I have promised myself to return. The first pretext for my journey was salmon-fishing with friends; but, as you can imagine, I caught few salmon, unskilful as I am at that kind of sport (it is also very difficult). And I soon restricted myself to fishing for pictures and landscapes.[10]

In the intervals of his salmon-fishing, the Colonel had watched his guest with fascination.

I once saw him take his coffee and pour it over a page to produce a tone that he fancied. He worked with anything. The end of a pen, his finger, a thumb-nail, anything seemed to do . . .
After leaving Braemar we went to Ballater, visiting Balmoral and Abergeldie on the way. Doré had then the illustration of Shakespeare in his head, and many were the discussions that took place every evening; and if we wearied of them Doré would borrow a fiddle and play about the village and on the bridge, to the great delight of the country-people.[11]

On 22nd June Doré sent Miss Edwards a watercolour sketch of 'a certain Lock Mike a few leagues from Ballater.'[12] Since March, so he told her, he had travelled from the extreme south of France to the extreme north of Scotland. 'When shall I go to London? I don't know. And yet I have very often been tempted . . . But I don't despair of escaping one of these days. I shouldn't like to let a year pass without paying a visit to London. I really love it.'[13]
He needed to escape; he was beset by family troubles. Writing to Harford, he explained:

My eldest brother [Ernest] has been ill for some time . . . I am much afraid that he is threatened with a serious brain disorder . . . My mother's health is not very good; her chronic bronchitis seems to me to be very much worse. That, too, makes me very sad and anxious. I am working

Ludgate Hill – a block in the street (*London – a Pilgrimage*, 1872)

incessantly, like one distraught, on things which will probably go to London.[14]

The following month, he himself was back in London yet again. Mme Doré, troubled by his absence, sent one letter after another.

I have received all your letters this morning [he answered on 21 July]. I thank you, and I ask forgiveness for being so brief in mine, and for writing so seldom . . . My life here is stretched out to the limit . . .

Every day I breakfast and dine with interesting and notable people. I have dined twice with the Lord Mayor, yesterday with the London Rothschilds, and this morning [sic] with H.R.H. the Princess Louise . . . Today I dine with a very interesting and singular notability, Mr Shaw, chief of the London Fire Brigade; and after dinner, which is given for me two hours later than the usual time, the officers are going to have manoeuvres in the large court of the general station with all the engines, pumps, machinery, ladders, and so forth; for one of the things on which they pride themselves in London is their Fire Brigade and their perfected art in extinguishing fires . . .

I embrace you very hastily because I must dress to go and dine with my amiable Fireman.[15]

Doré planned to be back in Paris on 1 August. He went home in a melancholy mood. On 5 November he explained to Harford: 'I must constantly listen to the voice of reason in order to be able to work. There is always despair in my heart . . . Pity me, the future seems very sad.'[16]

Doré was still desperate about the defeat of France, the loss of Alsace, the ill-health which beset him and his family. According to Blanchard Jerrold, he was also deeply in love. On one of his visits to London 'he had met a lady who became the idol of his dreams, and about whom he talked and wrote unceasingly – albeit he never told his love to the object of it.'[17] It is impossible to tell who she was, but perhaps she was the young woman whose likeness was found repeatedly in his work. Blanche Roosevelt reproduces a haunting picture of a woman, apparently

Baby. Pencil, 1870

in her twenties: gentle, serene and touchingly beautiful. One wonders why Doré decided not to declare his love for her. Perhaps she was already engaged or married. Perhaps he recognised from the first that his mother would not countenance any wife. In a letter of November 1873, so Blanchard Jerrold tells us, 'and in many subsequent letters, he bemoaned his fate – and said that even work would not efface for a short time the beloved image. He vowed that he had not made a single step towards forgetfulness.'[18]

12

Doré visited Spain with Baron Davillier; he could not have had a more expert guide. Jean-Charles Davillier was nine years his senior and he was an art historian: indeed, when he died in 1883 he was to leave a handsome art collection to the Louvre. Davillier knew every corner of Spain, he had been there countless times before he went there with Doré. The two men understood one another perfectly, and while they were in Spain they decided to publish their joint impressions. *L'Espagne* appeared under the Hachette imprint in 1874; it had no fewer than 306 engravings by Doré.[1] 'M. Doré is at home in Spain,' so *The Athenæum* observed, 'and, after his fashion, does justice to materials which affected him with unusual force. It is needless to describe the pictures before us, they are such as our readers know by the thousand.'[2]

It is true that Doré sometimes indulged in his love of horror. He showed a coach and horses tumbling over a precipice, a criminal gasping as he was garrotted. He was excited by the bullfights, and by the disembowelling of the horses. But even in the study of beggars at a cathedral door, or of the boatman at Valencia, he caught the grandeur of the Spanish manner. In *L'Espagne* he penetrated beneath appearances. We sense the authenticity of his Spanish drawings. The figures are real, and he has seen them. He has also seen the bulls led across the mountains in the moonlight for the bullfight at Valencia; he has seen the funeral cortège, led by lantern-bearers, making its way to some nocturnal burial. In this picture, and in his general view of the Alhambra, or La Torres Bermejas and the Generalife, he shows his mastery of light and shade. It is remarkable how in black-and-white he can suggest a torrid afternoon, a world of light and colour. *L'Espagne* is one of his most inspired books.

Mme Braun, who had been a family friend since his childhood days, added her comment. Whenever Doré drew Christ, she said, he drew a likeness of his brother Ernest. 'He also sketched his mother. I could not tell you how many times he drew her face,

The mills of La Mancha (*L'Espagne*, 1874)

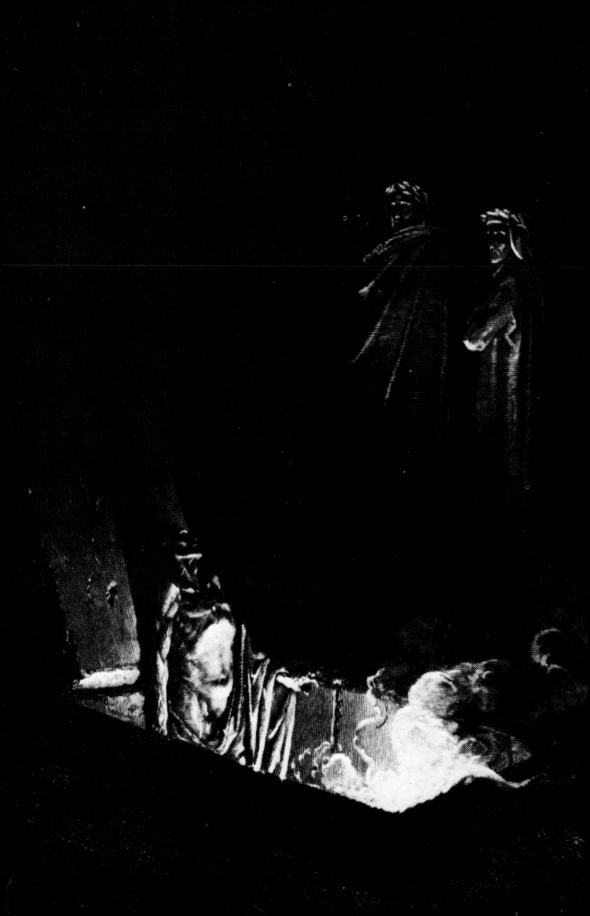

especially in his Spanish pictures. I know Madame Alexandrine at a glance in her counterfeit presentments by Gustave.'[3]

<p style="text-align:center">★　　★　　★</p>

The painter persisted. Jules Claretie gave him only measured praise in the Salon of 1874. Doré's *Martyrs chrétiens* seemed to him mere theatre. 'The stars shine in the deep blue sky as if produced by an electric light . . . I repeat, it is a fine stage setting.'[4]

The criticism was constant; but Doré continued his vast paintings in the rue Bayard. 'I've just finished the big picture which I'm sending to the Paris exhibition,' he told Amelia Edwards on 22 March 1875. 'The effort has been so great that I'm still exhausted; but in few days the tiredness will have vanished and I shall plough my furrow all the better. I hope that one of these canvasses, which represents Dante's Hell, will go to London this summer.'[5]

Doré's exhibits at the Salon of 1875 were criticised more harshly than ever. Zola put his finger on Doré's weakness. 'He imagined that great frames might give greatness to his works . . . It is a fundamental mistake.'[6] Claretie was no more benevolent.

> The illustrator of Dante wanted to transport a *block* from his edition on to canvas . . . No-one, since Martinn [*sic*], has contained thousands of men, or rather phantoms, in a frame as he does. But these dioramas and panoramas are the opposite of true, sincere and intimate art . . . All this may be décor, scene painting, done for the theatre, it is not in the least, it never will be, art. M. Doré's *Vagabonds*, those Spaniards with red and yellow clothes, standing out against an indigo sky, come much closer to real painting than this swarm of india-rubber and pasteboard bodies.[7]

There was indeed a constant sense of theatre in Doré's work. It was not surprising if the theatre sometimes seemed to be

Dante's *Inferno* (1861)

indebted to him. Arnold Mortier, discussing a play with a London setting, suspected that the beggars' costumes had been based on Doré's London illustrations.[8] Doré himself thought instinctively in terms of the stage. Charles-Marie Widor, the composer, once remarked to him that Tennyson's *Vivien* would make a fine libretto for an opera. 'Yes, you compose the music,' he said, 'and I'll design all the scenery and costumes.' Widor recalled that, even in this first conversation, Doré's conception of the scenes was as complete as if it had long been forming in his mind.[9]

The opera was not written or staged; but Doré, none the less, had a spectacular and definite influence on the theatre. Edward Gordon Craig observed that,

> as a producer, Irving absorbed much from the work of this Frenchman of prolific fancy . . .
>
> Sometimes [Irving] would take a whole design of Doré's and put it on the stage . . .
>
> The Irving sense returns to you over and over again as you turn each page of Doré's *Quixote*, and feel the curious romanticism . . . of every touch. In Doré's *Dante*, it is just as evident. All Doré contains seeds of Irving, and all Irving shows the influence of this excellent inventor . . .
>
> I, who owe a debt to Doré, know quite well what it was H. I. found so excellent . . . Drama expressed visually? Yes.[10]

<p align="center">★ ★ ★</p>

In 1875 Doré found himself at Plombières. He also crossed the Channel yet again.[11]

> When he arrives on his annual trip [recorded Edmund Yates], . . . his faithful old servant Jean spreads out his drawing and painting materials as soon as the luggage is unbuckled; and Doré's great London trouble is that he cannot get the early *café-au-lait* which he has at home, as he

Dante's *Inferno* (1861)

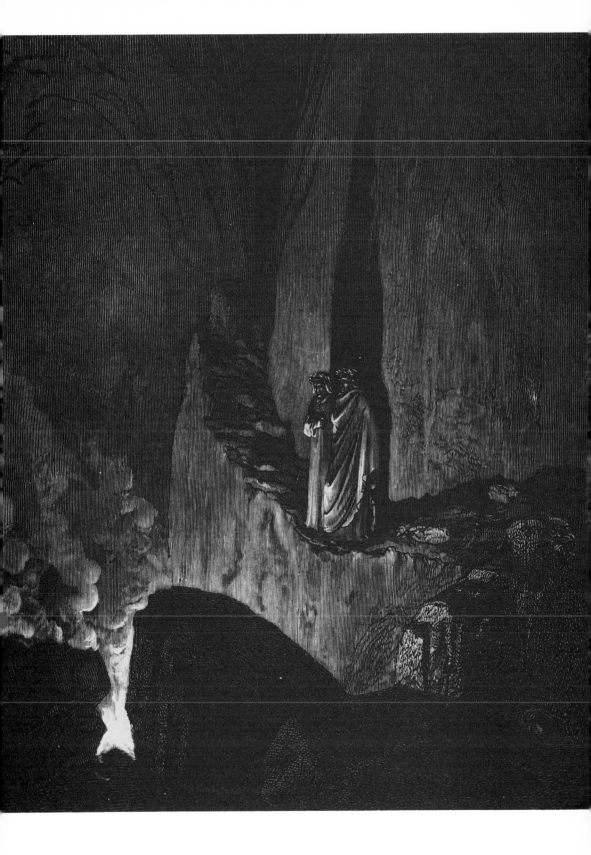

sets to work at six o'clock in the morning. . . . In London he will have the keys of the gallery in Bond-street at night, that he may be able to go there and have some hours in the morning at one of his pictures, before anybody, save the market-gardeners, is stirring.[12]

Every summer he was invited to the Prince of Wales's garden-party at Chiswick. It was there, it seems, on 5 July 1875, that the Prince presented him to Queen Victoria.

> Her Majesty [wrote Blanche Roosevelt] received the artist most graciously, and was pleased to mention some of his early works, which she said she remembered with great pleasure . . . With a child's straightforwardness and simplicity, Doré replied:
> 'It is I, Your Majesty, who remember with gratitude the encouraging influence some of the Prince Consort's words exercised upon me.'
> Doré referred to the admirable speeches on art which His Royal Highness gave to the world . . . The Queen held an animated conversation with Doré, until at last the artist, seeing the eyes of the Court fixed upon him, feared that he might be exceeding the limits prescribed by Court etiquette, and began to bow himself out of the Queen's presence. Her Majesty was even more gracious in her dismissal than in her welcome of the young artist. As Doré was retiring, she said, hastily and cordially:
> 'I hope to see you again, M. Doré. When you come to Scotland, I shall be at Balmoral, and you must come and see me.'[13]

Henceforward Doré was so ardent an admirer of England and of the British Royal Family that his compatriots reckoned him half English.

★ ★ ★

As for the Doré Gallery, it continued to flourish. The Reverend Francis Kilvert, on a visit to New Bond Street, admired 'a noble

picture of Paolo and Francesca . . . The anguish of death,' he
reported, 'is stamped upon her white and sharpening yet still
lovely features, but her soul is rapt above her pain in an ecstasy of
love.'[14] The Victorians delighted in Doré's sentimentality, and
in his drama. They were touched, too, by his religious leanings.
His Bible illustrations were reprinted by Cassell in their massive
tome, *Daily Devotion for the Household*. Preachers drew lessons
from Doré's work. At the Offord Road Congregational Chapel, in
London, the Rev. E. Paxton Hood took as the text of his sermon:
'*Ecce Homo*. Doré's Gospel in the Canvas.' Artists, he said,
'choose their subjects by instinct; one thinks a divine instinct
must have led this man . . . Great artist, I would say, go on.
Preach, preach still from your canvases the gospel of salvation
and immortality.'[15] Delorme recorded that in England Doré was
sometimes called 'the preacher–painter.'[16]

E. F. Benson, the man of letters, was to be less sympathetic. In
his memoirs he passed ruthless judgment on the Doré Gallery.

> All the year round the turnstile clicked to the shillings of
> the serious. Before the most important works there was a
> row of chairs and, if you were lucky, you could slip into a
> vacant seat and reposefully drink in the solemn thoughts
> produced by these masterpieces. They had all the technical
> merits which were characteristic of the period, even the
> pre-Raphaelites admitted the carefulness of their execution
> and the sublimity of their subjects, and in terms of paint,
> they were exactly on the level, in terms of ink, of the novels
> of Marie Corelli.[17]

★ ★ ★

Doré's English critics could be harsh indeed; and they were not
slow to recognise that he was out of tune with English themes.
On 19 February 1876, recalling his illustrations for *Idylls of the
King, The Athenæum* decided: 'It was a misfortune for artist and
poet that they were thus brought together.'[18]

The occasion for these acerbic remarks was a review of Doré's
version of *The Rime of the Ancient Mariner*. The scenes with
figures are perhaps the least successful in this work; there are

General view of Alhambra (*L'Espagne*, 1874)

inconsistencies of medieval costume, and some puzzling musical instruments. It is in fact a puzzling world which Doré presents. The décor is presumably English, yet the port to which the mariner returns is a mixture of Strasbourg and Mont St Michel. One wonders how carefully Doré read the text – if indeed he read the original at all. Five times after the albatross sank 'like lead into the sea', it is still shown hanging round the mariner's neck. However, Doré revels in the storm at sea, the overpowering waves, the polar regions, the water-snakes, the solitary ship on the seemingly boundless moonlit ocean. They have inspired some memorable illustrations.

The Athenæum thought otherwise. 'It is sad to find that the spirit of spectacular and spasmodic effort, the melodramatic effulgence of lurid fancy, have prevailed again.' The critic took a cynical view of the frontispiece. This showed 'a seaman sitting on a ship's mast, the rigging of which is, to say the least, questionable . . . The ship draped in icicles in a grey vista of frozen cliffs, and yet afloat in unfrozen water, . . . is,' said the paper, 'effective with the effectiveness of a scene in a "Christmas piece" in a theatre, not the deeper poetry of a work of art.'[19] The public seemed to share this opinion. Ten years after Doré's death, four hundred and fifty copies of the book – found in his studio – were sold unbound.

★ ★ ★

For some *le gamin de génie* had now become an uninspired middle-aged illustrator of books. For most critics – at least in France – his attempts at grandiose painting remained pretentious, and even grotesque. On 5 May 1876 Henry James wrote an article on 'Art in France' for the *New York Tribune*. He found the Salon unremarkable; he took strong exception to Doré's exhibit.

> M. Doré [he wrote] treats his genius now as you wouldn't treat a tough and patient old cab horse; I know of few spectacles more painful in the annals of art. Imagine a coloured print from the supplement of an illustrated paper magnified a thousandfold and made to cover almost a whole side of a great hall, and you have M. Doré's sacred picture . . . There is no colour – or worse than none – no drawing, no expression, no feeling, no remotest hint of details; nothing but an immense mechanical facility, from which every vestige of charm and imagination has departed.[20]

Zola's comments in *Le Messager de l'Europe* were strangely similar.

> How can one make Gustave Doré understand that he is very mistaken? He thinks he is doing great decorative

painting because, every year, he exhibits sixty square yards of canvas covered with paint. [*Christ's Entrance into Jerusalem*] is just a coloured print of inordinate size which makes even clearer the poverty of the style and the lack of real originality.[21]

★　　★　　★

Doré himself was tired and frustrated. Writing to Amelia Edwards, he confessed:

> I envy you, as I envy all those who – unlike myself – are lucky enough to see the beauties of the planet which we inhabit. My own life is just a perpetual dream of seeing all these wonders of the continents. Sometimes it is the Asiatic Orient which tempts me; sometimes it is the vision of the river of the Amazons which makes me want to set off on my journey . . . But, alas . . . I have the least free life in the world, the life most trammelled by engagements and by obligations. My nature always thirsts for independence, and it is thwarted every day by the duties which overburden me: duties which I should not have undertaken.
>
> When shall I be able to make a long and splendid journey, in other words take off five or six months and rush to the other side of the world? I don't know, and I don't see an immediate possibility. But it doesn't matter, I still insist on dreaming about it.[22]

Late that summer he set off, at last, on his travels. He paid a flying visit to London; then he and Canon Harford stayed with the Earl of Warwick, at Warwick Castle. Doré slept in the famous room panelled with oak from Kenilworth. 'Ma foi,' was his comment, 'c'est impérial!' The castle filled him with delight. As Blanche Roosevelt wrote: 'He knew Caesar's tower, Guy's tower, and the Bear tower by heart, whilst the magnificent grove of cedars was sketched under many lovely aspects; and, if we are not mistaken, the frontispiece of his *Orlando Furioso* is an etherialized, scarcely idealized, drawing of Warwick Castle and grounds.'[23]

Doré had already conceived a liking for English country houses; at Warwick it became an affection. He prolonged his stay. He and Lady Warwick drew one another's portraits. He presented her with a folio copy of *The Ancient Mariner,* an engraving of lions eating Christians in the Colosseum, and an engraving of monks at prayer.[24] He drove round the countryside in her pony-carriage. As an admirer of Walter Scott, he visited the ruins of Kenilworth Castle. He later visited Stratford-on-Avon. He made no sketches of the place – he did not need to make them; but he was more than ever bent on illustrating Shakespeare.

On 4 October, from the Hôtel du Cygne, at Montreux, he explained to Amelia Edwards:

Dear Mademoiselle,
 I have not come from the Dolomite country, or from the third cataract of the Nile; but I have pitched my tent in so many different places in the last two months that I seem to have made a tour of the world this summer. I hardly stayed in London at all this year; I stayed in the country nearly all the time which I devote every year to my visit to England. I therefore visited several places which are famous for their picturesqueness: among them were Durham, Warwick, Kenilworth, Stratford . . . I have just travelled across Switzerland, which I admire more than ever, and I have ended these many excursions with a stay in the village of Montreux: a delightful place on the eastern shores of Lake Geneva. This is my eighth visit to Switzerland . . . I shall come back with a rich harvest of studies and plans for pictures.[25]

It was perhaps on this visit to Switzerland that he lost his passport in Lucerne, and he was brusquely questioned by the police. He asked to see the mayor. 'You assure me,' said that worthy, 'that you are M. Gustave Doré, and I believe you. But you have an excellent means of proving it to these gentlemen here.' Doré drew a lightning sketch of some market women outside the window. 'Your passport is perfectly valid,' the mayor told him, 'but let me keep it as a memento. I will have another delivered to you at once in the usual form.'

13

I am particularly and especially absorbed in my work for a
great illustrated Shakespeare [so Doré told Amelia Edwards
in February 1877]. I am assembling as much material and
archaeological information as possible. But I am not yet
ready to publish anything, because I have the greatest
[ambitions] for this work, and I want to be as strong as
possible against the assaults of the critics. I think it is wise
to go very slowly.[1]

In the meanwhile he prepared his exhibits for the Paris Salon;
and in 1877 he first showed his skill in a new form of art.

It was [remembered Jerrold] in the back kitchen of the
little house in Dean's Yard, Westminster (the residence of
Canon Harford), that Doré first took clay in hand, and tried
his skill in the plastic art. He endeavoured to realize a head
of the Saviour . . . He produced a vigorous, but a rough and
harsh work, that was left to crumble in the back garden; but
it had served to open to the artist a fresh field for his
imagination . . . When he went back to Paris he partitioned
off a corner of his studio in the Rue Bayard, and applied
himself to the mastery of the sculptor's material and
technique.[2]

Doré's group in the Salon of 1877, *La Parque et l'amour*, was
distinguished, wrote Delorme, 'by the original seal which Doré
impresses on all he does.'[3] His painting was, predictably, less
appreciated. The *Athenæum* critic, vehement as ever, declared
that 'the Salon would be elevated by the absence of a gaudy
picture of M. G. Doré's. It is called *Jésus condamné*.'[4] An English
critic, W. Renton, published a vigorous onslaught on Doré, and
lamented the decline of his powers.

<p style="text-align:center">★ ★ ★</p>

For the last ten years, Doré's failures had outnumbered his
successes in art; but he still remained a social lion. The

journalist Edmund Yates recorded him in the rue Saint-Dominique.

> You must [wrote Yates] catch Gustave Doré in the vein –
> and he is not so every day – to know that he is an admirable
> talker, that he has humour (which is rare in Frenchmen),
> that he has thought much on many subjects, and that he has
> read, bringing a poetic temperament to the task, good books
> which railway-library readers have never heard of. He
> understands Dickens as well as Dante, and has literally
> revelled for years in Shakespeare . . .

> Doré has not, in his address, the ceremonial courtesies of
> the conventional Frenchman. His face brightens swiftly as
> Dickens's used, and he gets quickly through the *banalities*
> of meeting, to touch the subject on which his vehement
> unresting mind is bent . . .

> The work done already is immense; but it has not yet
> taken all the boy out of the man . . . When he has,
> accidentally, a friend or two who have dropped in at the
> studio in the morning, and whom, in his hearty hospitable
> way, he has invited to breakfast round the corner at the
> Moulin Rouge – and where can a man make a better
> breakfast on a summer morning? – and when these are
> familiar spirits, Doré will toss his paint-covered coat aside,
> throw himself upon his back on a rug, and, before going
> out, let his pugs and his terriers run over him, and have a
> rough play with him, while Jean holds the unpainted coat
> ready for his master . . .

> Let us follow him to the Moulin Rouge. Never was the
> human frame filled with intenser life. We have known only
> one individual in whom the faculties of observation and
> apprehension were as acute and unresting as those of Doré,
> and that was Charles Dickens. It is easy to see why Doré
> delights in the author of *Pickwick*, and is for ever talking
> about him. Doré recognises in the great novelist powers
> akin to his own.

> Doré, however, has only fitfully that which never forsook
> Dickens, viz. the power of enjoyment, the delight in life,
> the love of laughter. But when Doré *is* in the vein, his

Victor Hugo. From a photograph by Charles Hugo, c. 1854

spirits know no bounds. His fund of anecdote, his humorous observation, his store of reading, and, which is more important, his store of thinking, all heightened by a marvellously strong and faithful memory, command the table . . .

Doré goes into 'the world.' He is to be seen on first nights at the theatre; he is a steady frequenter of the opera . . .[5]

He went to hear Adelina Patti in *La Traviata.* In April 1877, the first night of *Le Roi de Lahore,* by Massenet, was attended by the President of the Republic, the Emperor and Empress of Brazil, and by *le tout Paris,* Doré among them.[6]

Doré went to official receptions and to embassy festivities; he

attended the most brilliant private *soirées*. He also dined, from time to time, with Adèle Cassin, the surpassingly rich demi-mondaine who (thanks to the banker Édouard Delessert, one or two Barons de Rothschild and the founder of the Galerie Georges Petit) now lived in a splendid *hôtel*, I, rue de Tilsit, with a view of the Arc de Triomphe and a fine collection of works of art. Mme Cassin – one day to be the Marquise Landolfo Carcano – invited distinguished men to dinner, but they took care not to bring their wives. At the rue de Tilsit, Doré met Gambetta and Léon Bonnat; he also met Dumas *fils,* who took Adèle as his inspiration for his play *Denise.*[7]

Doré was also a friend of the Comtesse de Beaumont, sister-in-law of Marshal MacMahon. Mme de Beaumont was, it is said, beauty and seductiveness incarnate. Separated from her husband, she had created herself a salon in her exquisite little *hôtel* in the avenue de l'Alma. Her musical evenings were superbly organised, her dinner-parties uncommonly elegant; and the Comte de Maugny recalled that Doré was among her regular guests. 'Gustave Doré was an incorrigible dreamer, a good fellow if ever there was one, but he was easily offended, and he readily plunged into endless discussions with Carolus Duran, that hidalgo transplanted on to French soil . . . Paul Baudry . . . tried with sporadic success to act as conciliator between them.'[8]

Yet despite his social life, Edmund Yates maintained, Doré was not fond of society,

> for the sufficient reason that it interferes with his art. Although, through a long, hot evening, he will take nothing more than a couple of glasses of water, the heat and the crowd and the talk tell upon him; and he wants a cool refreshed brain and a steady pulse at six o'clock in the morning. His pleasure is his quiet evening at home, talk in the company of a few cultivated friends – he affects the society of doctors particularly – and music among musicians, and without an audience of mere toilettes.
>
> 'An artist, sir, should rest in art,' said the Laureate . . . Doré lives and moves and has his being in his art.[9]

This was indeed so. Sarah Bernhardt and Doré once had *déjeuner*

with Victor Hugo. During the meal, Sarah fainted (she maintained it was from mortal boredom). When she recovered consciousness, she was lying on a sofa, 'and facing me, taking sketches, was Gustave Doré. "Oh, don't move!" he cried. "You were so pretty!" The phrase was most inopportune, but it charmed me all the same, and I obeyed the great draughtsman, who was one of my friends.'[10] Doré felt a great *tendresse* for Sarah, and he painted her portrait.

<p style="text-align:center">★ ★ ★</p>

Edmund Yates had noticed Doré's moods. As he approached his fiftieth year, Henry Vizetelly found him

> in a state of chronic wretchedness, solely because French art critics refused to recognise in him a great painter . . . Doré himself regarded the tall pale Christs and gigantic apostles that filled his colossal canvases as his grandest works, and used often to say: 'If it were not for my drawings more justice would be rendered to my painting.' So convinced was he of this that in his later years he declined to have his drawings spoken about, and chance acquaintances, who thought to please him by complimenting him on their marvellous power and originality, speedily discovered their mistake.[11]

In the Salon of 1878 his sculpture included a group which showed, 'with the most striking truth', the martyrdom of Glory.

The longer Doré was refused recognition as a painter, the more desperate his efforts became: the more enormous his canvases, the more strident his colours, and the more melodramatic his themes. In sculpture, too, he turned to the immense and the ornate. In the palace in the Champ-de-Mars, during the Exhibition of 1878, the grand hall was adorned by a monumental candelabrum. Its principal figure was that of a woman, standing on a crescent moon like Murillo's Virgin, and clad in a tunic sown with stars. It personified Night; and flames of bluish light flickered from hidden gas-jets, and shed a glow of mystery about it.

Doré's most spectacular exhibit was, however, an enormous vase,

> a monumental vase, 2.5 metres high, with the pot-bellied shape and thin neck of Chinese porcelain vases . . . The artist [wrote Delorme] has given it a green bronze patina so that its gay tone should harmonize with the gaiety of the subject which he has sculpted on the rounded loins . . . This subject is the poem of the vine . . . Personally, I consider this vase to be one of the most extraordinary works that has ever come from the hands of man . . . No-one has produced anything, in any epoch, equal to this work.[12]

The vase was brought by an American, and it was finally shipped to San Francisco.

<p align="center">★ ★ ★</p>

In January 1879 its creator was promoted Officier de la Légion d'honneur. Doré was only honoured, so the rumour went, because Agénor Bardoux, the Minister of the Fine Arts, was a friend. The diplomatic manoeuvres had been enough to destroy his pleasure.

While his vase adorned San Francisco, another example of his sculpture enhanced the wedding-cake world of Monte-Carlo. In January 1879 the Salle des Fêtes at the Casino was officially inaugurated. This remarkable period piece was the work of Charles Garnier, the architect of the Paris Opéra. On either side of the vast façade was a niche adorned with a sculpted group: *La Musique*, by Sarah Bernhardt, and *La Danse*, by Gustave Doré.[13]

In April Doré found yet another outlet for his gifts. A group of French watercolourists founded the Société des aquarellistes français; they organised an exhibition in the rue Laffitte. Doré was to exhibit with them every year for the rest of his life. Grandiose as ever, he tried to prove that the resources of the *genre* were unlimited; he painted a lifesize water colour portrait of his mother. This portrait, said Delorme, was 'intensely true'.[14] Blanche Roosevelt confirmed that it was an astonishing likeness.

This picture represents Madame Alexandrine Doré as exactly as though her counterfeit presentment were a living woman about to open her lips and speak. She is seated in a red plush chair; one shapely hand holds a book, the other is slightly uplifting an eyeglass, in an attitude she frequently assumed when a stranger's face was visible amongst her guests . . . The little head is poised with steadfast dignity, and on it is perched the mauresque violet and white turban which, as M. Lacroix said, gave Madame Alexandrine the look of an accomplished Spanish zingara. And she sits so well, too, in her incarnadine chair. Her position is one of expectancy, yet unconscious ease. Her amethyst misty dress drapes her limbs in graceful folds; a heavy gold chain hangs from a brooch and seems by its sheer weight to indent a rich broidered kerchief folded across her comely bosom. One noticed all these things in the picture because they were part and parcel of Madame Doré herself.[15]

Mme Doré was now over seventy. She suffered from chronic bronchitis, and this year she was seriously ill. Doré had his work-table brought into her bedroom, and he sat up with her night after night, drawing away at his blocks by lamplight.

Every social tie was severed, every recreation connected with the outer world was ignored by him; in short, he thought of nothing but his mother's illness . . . Only near break of day, when she was wont to fall into a troubled sleep, did the artist snatch a moment of repose. In the morning, as soon as she stirred, he was again at her bedside, and when compelled to leave her by imperative business, he went off wearied and fatigued to work at his huge canvases in the Rue Bayard.[16]

In the Salon of 1879 he showed his savage picture, *La Mort d'Orphée*. This picture, said *The Athenæum*, 'depicts with abundant energy, not to say fury, a subject well suited to the artist's mind.'[17]

Sarah Bernhardt. From a photograph by Nadar

Doré needed to escape; as usual he chose to go to England. On 12 June, in a letter to Amelia Edwards, who was now living near Bristol, he announced:

I expect to go to London in a few days, and to spend the Season there . . . You really must come from time to time and listen to the tone of the great capital. One only remains in the literary or artistic movement on this sole condition. I like to think, Mademoiselle, that your health is still very good, that is to say the health of a *worker*. I firmly believe that *we* are the healthiest, and for the simple reason that our life is the most regular . .. I am among those who believe that the most excessive work, if it is continuous, is less *wearing* than boredom, intemperance or idleness.[18]

He spoke with Alsatian determination; but the previous year he had begun to suffer from a heart condition, and Blanche Roosevelt records that his health was now much impaired. 'He suffered terribly from a morbid condition of the heart, and from continual indigestion. As soon as he was possessed by any new inspiration, he neither ate, drank, nor slept until he had put it to a practical test, but spent hour upon hour at a stretch in his studio, and never took any exercise.'[19] Guillaume Dubufe *fils*, son of the portrait painter, noticed that his body looked boneless. 'In his buttoned-up overcoat, he was rather like a doll from which the stuffing would fall at the slightest prick.'[20]

Doré found himself in London in the famous summer when Sarah Bernhardt was taking it by storm. She had just added a chapter to her legend by acquiring a menagerie, and by letting the animals loose in the garden in Chester Square. 'We were helpless with laughter,' she remembered, 'myself, my friend Louise Abbema, the artist [Giuseppe de] Nittis who had come to pay me a visit, and Gustave Doré, who had been waiting for me for two hours.'[21]

★ ★ ★

Doré had now turned to Italian literature. He had illustrated a translation of Ariosto's *Orlando Furioso*. His *Roland Furieux*

was published by Hachette this year. For the first time, thanks to the Gillot method of reproduction, he did not suffer the hazards of engraving. All six hundred and eighteen illustrations were facsimiles of his own work.

'I sing the damsels, knights and battles, the loves and gallantries, the bold deeds of the time when the Moors of Africa crossed the sea and did much harm in France.' So began the first canto; and Doré caught this world of chivalry: the damsel galloping on a white steed through a sombre forest, the duel between Comte Roland and Renaud. There is a storm at sea which recalls his superb sense of composition, his feeling for feverish activity; there are his familiar monsters, and a Doré castle set so high on its isolated crag that, once again, we wonder how a builder could have reached it. At times the illustrations have a false theatrical air, and suggest the work of some lesser Watteau. All too often they reveal Doré's persistent love of cruelty. Repeatedly we see a monster devouring his prey: a woman shackled by her wrists to a cliff face. There is a mass decapitation, and fourteen heads roll down a mountainside. The Chevalier d'Angers spears five enemies at once; a warrior has his skull cleft by a sword. Clusters of corpses hang from a tree, grim in the moonlight. Rodomont hacks his enemies to pieces. Doré is not concerned with beauty; he is still concerned with violence, after a career of more than twenty years. *Roland Furieux* was to be the last classic which he illustrated.

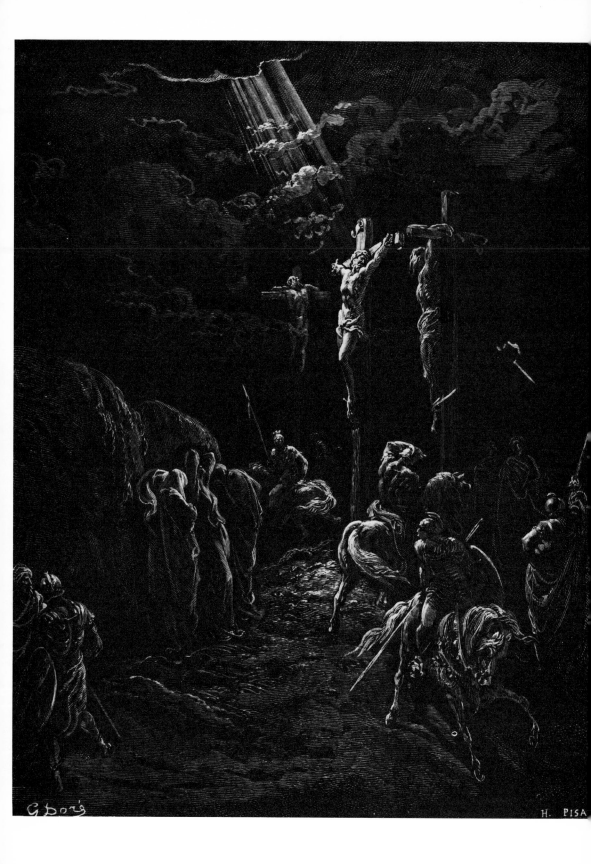

IV

'So awful a void'

1881–1883

14

On February 10 1880, Edmond de Goncourt once again met Doré. He allowed himself some acid comments:

> He is an Alsatian, and an Alsatian, even with talent, is an inferior Frenchman or German. On top of that, he has a terribly disparaging character; he recognises no talent in any contemporaries, however gifted they may be, except in himself.
>
> He said only one true thing. He said that illustration is only pleasing for the artist with those geniuses of the past who say: 'He entered a dark forest, and found himself in front of a palace with walls which seemed to be made of diamonds.'[1]

Perhaps, as Millicent Rose observes, Doré's whole art as an illustrator sprang from his unremitting search for the palace with diamond walls.[2] He was a belated Romantic; he lived outside or beside his age. His work was his escape into fantasy.

Critics had recognised this truth for years. They had also recognised its implicit danger. As early as 1866, Zola had observed:

> Never did an artist show less concern than he does for reality . . . He lodges at the hostelry of the fairies, deep in the land of dreams . . .
>
> Reality, one must admit, has sometimes taken its revenge. You do not shut yourself up in a dream with impunity. A day comes when you lack the strength to play the creator. Besides, when works are too personal, they are certain to repeat themselves; the eye of the visionary is always filled with the same vision.[3]

Zola's forebodings had been justified. Now, in 1880, he reflected on Doré at the end of his career. 'It is said that M. Gustave Doré is very embittered by his lack of success as a painter . . . He blames the stupidity of his contemporaries . . . M. Gustave Doré has only himself to blame; to-day he is simply being punished for his disdain of nature.'[4]

★　　　★　　　★

144

Doré's art was in decline. In March 1881, his existence was in disarray. After two years of illness, Mme Doré died. On 16 March, on the morning of her funeral, he wrote to Canon Harford: 'A black unbridgeable gulf seems to yawn before me. You are a priest, my dear friend; I implore you, send up all your prayers to heaven for the repose of her dear and sainted soul, and for the survival of my own reason. I am absolutely overwhelmed by despair, discouragement, and fear of the future.'[5]

In another letter he signed himself: 'G. Doré, *chrétien militant*.'[6] But religion could not bring him solace. 'I am absolutely prostrated,' he confessed to Blanchard Jerrold, 'and, alas! I am absolutely alone . . . I had lived for a very long time with my eyes fixed on this fearful ordeal; but I had not imagined so awful a void.'[7] On 26 April he lamented to Canon Harford: 'Work does not console me. Nothing consoles me, for I am alone, alone, alone, without family and almost without friends . . . I have had the improvidence not to build up a home for myself, not [to find] someone to lean upon. Without that, life is just a cursed and ridiculous thing.'[8] A few days later, writing to Amelia Edwards, Doré repeated: 'For two years at least I lived with my eyes fixed on this formidable and *predicted* ordeal (for my mother's condition had become so precarious that I had been warned by several people, and I had long been forbidden to hope at all). I still did not imagine the cruelty of this eternal farewell.'[9]

Doré was never consoled for his mother's death. Victor Fournel remembered that his solitude 'accentuated a sort of misanthropy which his friends could see developing year by year.'[10] He quarrelled with his brother Ernest; he later attempted reconciliation, but his last legal will excluded Ernest from any inheritance.

He lost himself, now, in a grand enterprise: his monument to Dumas *père*. He refused any remuneration. He wanted to pay tribute to Dumas, and to ensure his own renown as a sculptor. Dumas's friend, M. de Leuven, was to recall how Doré had worked 'night and day with feverish ardour.'[11] 'He smoked too much,' Claretie continued, 'and he stayed up too late. He considered rest to be wasted time – while in fact it means longer life.'[12]

His work was desperate, his solitude remained unbearable. He

reflected, yet again, on the marriage that he should have made. On 30 December he wrote to Canon Harford: 'I have been wrong to let myself glide on to my present age without establishing a home and hearth . . . Now, more than ever, I regret this failure.'[13] On 15 March 1882, at Princess Mathilde's, he seated himself beside Edmond de Goncourt,

> and said to me without preamble: 'You'll see, we shall end by marrying two old Englishwomen!'
> And when I said to him: 'So you find celibacy a burden?' he confessed that he wanted continuation, he wanted to be survived by a child.[14]

The thought remained with him. On 5 April he wrote in a letter that the loss of a child was 'the only drawback, to my mind, of the married condition.'[15]

At the Salon of 1882, he was classed *hors concours*. Tribute was finally paid to the painter.

That November Jerrold came to see him in Paris.

> We talked about the studio he was to build, by the Parc Monceau, over our breakfast at Ledoyen's, whither he had migrated, after the final closing of the Moulin Rouge. He was sad, and complained, as usual, that since his mother's death he had led a lonely life. He talked about marriage and then . . . [about] the disadvantages of a man of fifty entering upon matrimony with a young girl. He was even more energetic when he came to the picture of a reasonable marriage with a person of suitable age. That would not suit him. 'En attendant,' he broke off, 'let us smoke.' And he smoked, and, while his dreaming eyes wandered over Ledoyen's shrubs, he talked about his statue of the elder Dumas, which he had been examining in his studio . . .
> From Ledoyen's that November afternoon we turned towards the Faubourg Saint-Honoré, Doré talking in a subdued manner that was unusual with him, and we halted at the corner opposite the Élysée. I was going to turn back towards the studio with him, . . . but he took my hand and said, 'Don't fail me at breakfast when you come back. Adieu,

mon ami.' He disappeared in the shop of a book-seller opposite . . . I thought he had aged much of late, and I walked away somewhat sad to think that he should feel lonely and adrift, at fifty.[16]

He need not have felt adrift or lonely. During the last year he had fallen deeply in love with a young woman in Paris. His mother was no longer there to prevent the marriage; and, through the negotiations of friends, the marriage contract had recently been drawn up. Blanche Roosevelt maintains that the match would have been in every way suitable. This time it was death that prevented it.[17]

<div align="center">★ ★ ★</div>

On 31 December, Doré gave a dinner-party at the rue Saint-Dominique. It was meant to welcome in the new year; but it was mortally dull, and he himself was silent and withdrawn. On 6 January he was fifty-one. A fortnight later, on Saturday, 20 January, he rose at his usual hour.

> He went into the billiard-room, and played a little alone; then returned to his bedroom to finish his dressing. He was expecting a call from a friend. Suddenly [recorded Jerrold] he called that he was in great pain, fell forwards over a table, and finally backwards, over the barber's basin that was at hand, cutting his temple. He remained for some time unconscious, and was persuaded with difficulty by the doctors to go to bed. He lay prostrate and sad, even to tears. When his man from the Rue Bayard reached him he said: 'Ah, mon ami, vous ne me reverrez plus Rue Bayard. Je suis perdu. J'ai trop travaillé.'[18]

He had had a severe stroke. Next day he rallied. He longed to recover, and to finish his illustrations for Shakespeare. 'My Shakespeare! My Shakespeare!' he murmured. But '*Romeo* was never to be finished; *Timon* remains a mere shadow upon many soiled sheets of paper; *Julius Caesar* lies scattered upon pages of scratches and confused lines.'[19] At half-past twelve on the morning of Tuesday, 23 January, Doré died.

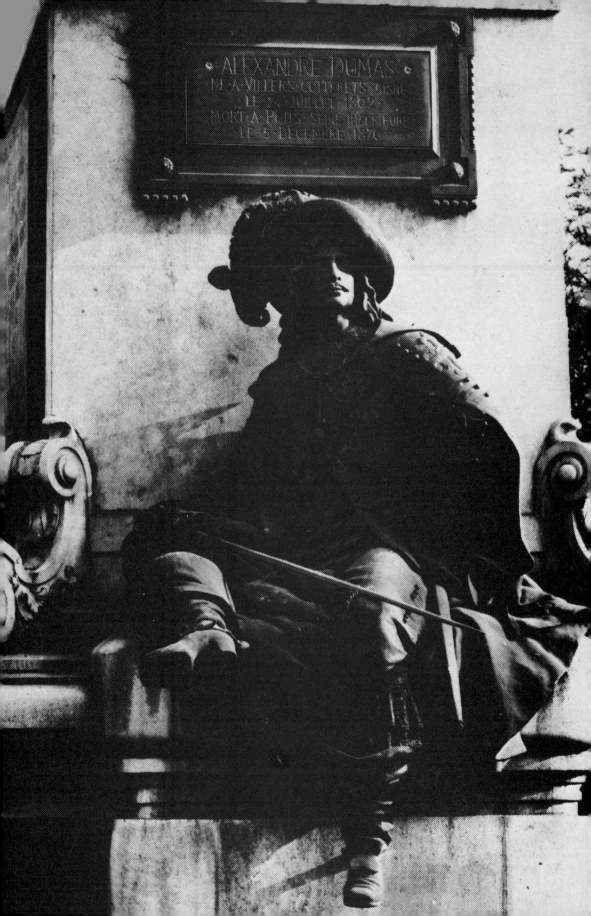

V

Postscript

He was far from looking his age [wrote Victor Fournel] . . .
For some time his humour had grown darker, as if he had
felt the approach of the grave; but his body and his mind had
remained in full possession of their power and activity. One
would have thought him 35 to 40 years old at most. I saw
him again on his deathbed, on the eve of his funeral, in the
midst of the wreaths and bouquets piled up by the pious
hands of his friends; he seemed to have grown ten years
younger still. Death, in touching him, had given the face of
this great worker an air of supreme calm and repose.[1]

The funeral was held on 25 January. The correspondent of *La
Revue politique et littéraire* noticed the apprehension on the
faces of the mourners at Sainte-Clotilde. Doré had died
suddenly, he had died in the prime of life. The event disturbed
his contemporaries. But it was not only 'everyone's personal
preoccupation which betrayed itself on this grievous occasion.
Gustave Doré was loved. M. Alexandre Dumas *fils* said so in an
eloquent speech, in which he spoke a good deal about his father.
He wanted to associate the name which was dearest to him with
that of the friend whom he interred. It was a pious thought
[continued the same correspondent] . . . Yet do you not think
that on the day of a funeral it should only be a question of the
dead?'[2]

Dumas's oration at Père-Lachaise had, in fact, been appro-
priate and touching.

It is not [he said] only admiration, it is not only friendship
which makes me speak beside the great artist's tomb. With
that enthusiasm, that generosity which were fundamental
to him, Doré . . . had spontaneously and modestly offered
to execute . . . the statue of the author of *Les Trois
Mousquetaires* . . . He gave this great work all his time, all
his talent. Perhaps he even gave it his life. Who knows if
this monument, which absorbed him at night, this
monument which he finished in six months, did not
occasion the illness from which he died? . . .

Gustave Doré on his deathbed. From a photograph by Nadar

It is, then, as one of his brothers that I pay tribute to his memory. It is, alas, a tribute which I cannot, like him, cast in bronze. I bring my honest admiration and my pious, useless gratitude.[3]

Doré was buried next to his mother. In his studio there remained countless sketches for the work he had been unable to complete.

\star \star \star

The year of his death saw the publication of *The Raven*, by Edgar Allan Poe. In this, the last book which Doré illustrated, he had drawn a series of variations on 'the enigma of death and the hallucination of an inconsolable soul.'[4] Death, with his sickle, waits beside the fire. The raven hovers over the corpse; and, finally, we are left with the sphinx of death: a sphinx, with a death's head, brooding above a promontory, on the mystery which Doré himself had now come to solve.

<p style="text-align:center">★ ★ ★</p>

In April 1883, Guillaume Dubufe *fils* published an acute and sympathetic appreciation of Doré. 'He is one of the interesting figures of our anxious age. He was both great and small, like his time, with the same doubts and the same aspirations . . . He will take a splendid place in that list of decorators who sometimes give the tone of their age much better than weighty philosophers or pretentious artists.'[5]

Now that Doré had died, it seemed that his creative powers would be acknowledged, and that 'the crime of fecundity' would be forgiven him. He would be recognised as a symbol of protest against the classification of modern art. *The Athenæum* allowed itself to be almost generous: 'However much he abused his powers, . . . Doré did invent new things for us . . . Let us take this wonderful genius as a whole, and be thankful for what he did, forgetting what he had better have left undone.'[6] Jules Claretie spoke sadly of what Doré might have done, had a normal span of life been granted to him. 'He had superb ambitions, dreamed of vast spaces which he would have liked to cover with frescoes, of giant palaces which he would willingly have peopled with statues . . . He felt himself to be cramped in his art. He would have liked to go further, *to touch the beyond!*'[7]

His sense of theatre would have made him a dazzling scene-designer, a remarkable decorator of great buildings; but he had not even fulfilled his hopes as an illustrator of books. He had not turned his hand to Hoffmann or Plutarch, Homer or Thomas à Kempis. '*Romeo* is begun,' so he had written, once, to Jerrold, '*Timon* is ripening, *Julius Caesar* is coming out, and *Macbeth* is nearly finished.'[8] He had worked on Shakespeare for several

years, he had hoped to make this enterprise his masterpiece, but he had not lived to finish it.

On 5 August 1883 Edmond About, now an Academician, delivered a speech at the prizegiving at the Lycée Charlemagne; he paid homage to the artist who, some thirty-five years earlier, had attended the Lycée with him, and had already shown his artistic powers.[9] On 4 November Doré's statue of Dumas *père* was inaugurated in the place Malesherbes. It was a spirited and heartfelt tribute to the novelist whose fecundity, verve and invention had matched his own. Doré had looked forward to this day as one which might bring him belated glory; and it did indeed establish him as a sculptor.[10]

In 1887, in *Les Graveurs du XIXe siècle*, Henri Beraldi praised Doré's achievement as an illustrator; but 'Doré cannot be dissected,' he concluded, 'he must be taken as a whole. His work is then that of an extraordinary man: indeed, of a man who is unique.'[11]

* * *

By 1902, thirty-five years after its inception, the Doré Gallery was losing its popularity. The proprietors began to let off rooms for other purposes. Doré's big pictures were still in view, but visitors could also see Russian peasant art, Picasso or Sickert. In April 1914 the gallery was hired by the Italian futurists. During World War I, the Doré canvases were shipped to America. Some say that they were lost at sea; whether or not that is so, they have disappeared.[12]

There are still monuments to Doré in a strange variety of places. In Bourg-en-Bresse, a street near the Lycée, which Doré once attended, now bears his name. In Paris, in the Musée des Arts Décoratifs, there is a huge gilt copper clock which Doré designed. It represents a terrestrial globe. Time stands at the Pole, cutting down troops of little cupids. The motif, Time destroying Love, symbolises a melancholy truth. The clock was the bequest of Alice Ozy. She had asked that a sculpture by Doré should mark her tomb; and at Père-Lachaise her resting-place is duly adorned by his statue of the Virgin and Child.[13]

Yet, whatever his versatility, however prodigious his other

gifts, however much he longed to be recognised as a serious artist, it is as an illustrator of books that Doré is remembered; and it is as an illustrator that we must assess him.

Doré had originated a new style in art, 'developed a new taste in the public, and discovered capabilities in book illustration which were not previously suspected'. So wrote a critic during his lifetime. In his own line, Doré left no equal, and indeed no successor.

As he said himself, he carried collodion in his head. He had an astonishing visual memory. With a few hasty pencil marks in his notebooks, he could fix the essentials of a scene in his mind. Yet his gift was not merely an uncommon faculty for observation. As Dubufe remarked:

> Thoughts sprang fully armed from his brain, so that nature no longer had anything to add; whence it came that his fantasy took the place of reality, and that unconsciously he acquired the habit of inventing instead of feeling, of thinking instead of seeing . . .
>
> This prodigious and charming composer, this tireless inventor, this musician who orchestrated with black and white, was wrong perhaps to want to leave the noble realm of his imagination.[14]

If Doré observed the world about him, he was not a realist by nature. His purpose, as E. C. Stedman said, was to excite the imagination and the soul

> by his marvellous and often sublime conception of things unutterable and full of gloom or glory. It is well said that if his works were not great paintings, as pictures they are great indeed. As a 'literary artist,' and such he was, his force was in direct ratio with the dramatic invention of his author, with the brave audacities of the spirit that kindled his own . . . He was a born master of the grotesque, and by a special insight could portray the spectres of a haunted brain. We see objects as his personages saw them, and with the very eyes of the Wandering Jew, the bewildered Don . . . The lower kingdoms were called into his service; his rocks,

trees and mountains, the sky itself, are animate with motive and diablerie . . . Beauty pure and simple, and the perfect excellence thereof, he rarely seemed to comprehend.

Doré was a consummate draughtsman. It seems as if he kept on his fingers a little of the grandeur of the books he touched. It also seems as if he expressed – perhaps unconsciously – his private dreams and nightmares, the manifold complexities of his nature.

★ ★ ★

'*Un gamin de génie*'. So Théophile Gautier had described Gustave Doré; and it is perhaps the most familiar phrase that was applied to him. It was succinct and largely true. For Doré died at fifty-one, yet in a sense he had never reached maturity. He had always been his mother's child, from the day of his birth to the day of her death, forty-nine years later, indeed to the day of his own death, which followed it so soon. Mme Doré had denied him his emotional freedom, the experience of life which is, above all, essential to the creative artist. In doing this, she had largely destroyed him. Her selfishness (and perhaps his weakness) left him an unhappy bachelor, childless, and condemned to solitude. It drove him to work with such feverish, unremitting energy, that he was burnt out by middle age. Doré's work was atrophied by his immaturity, and by this all-consuming relationship.

In many ways his illustrations reflect the fact that he had not lived. His work was full of quotations from other artists: from Michaelangelo, Raphael, Blake and John Martin. His manner varied from that of Murillo to that of Guys. It is true that out of this eclecticism there emerges an integrated style, born of his own exuberance and the energy of his imagination. But imagination too often takes the place of reality. It is plain that Doré learned the anatomy of men from the study of works of art. His women are drawn without interest, let alone with passion. Indeed, they make one wonder if he was afraid of women. Arthur Kratz, the friend of his schooldays, seems to have been the most intimate friend of Doré's life.

Yet perhaps no-one was intimate with this strangely disturbed human being: this man who still, in middle age, behaved like an

exhibitionist child. Doré's conjuring tricks, his terrifying acrobatic feats, suggest a child demanding attention. His love of the theatre, of charades, of dressing up, suggest a need to escape, to forget his own identity. So many of his illustrations record a fascination with violence, a concern with mutilation and deformity, torture and death, that they seem to spring from a personal obsession. Perhaps the artist is attempting to rid himself of his nightmares by committing them, again and again, to paper. Doré is not merely haunted by the Alsatian landscapes and the Gothic architecture of his childhood; he seems to be haunted, still, by the fears which had beset him in his infancy and boyhood. Tom Thumb marking his trail with stones as he goes into the forest, is Doré losing himself, at night, in the forest at Barr.

'The character of this talent is a grandiose sadness, which takes pleasure in confused fantastic visions.'[15] So *La Vie parisienne* had once observed. The visions were Romantic, picturesque, exciting, but they had no spiritual depth. As Edmund Ollier remarked,

> [Doré] seldom suggests to you anything finer than what he represents. He is wanting in those indescribably subtle touches which reveal more than they define. His main object is to be popular, and that object he never forgets . . .
>
> He sometimes reminds you of the contrivances of the scene-painter, and this is precisely on those occasions when the highest inspiration is most required. The fact is that M. Doré can seldom entirely get rid of his quality of a Frenchman. He cannot lose himself in his subject – partly on account of his technical skill, and partly because he partakes of that Parisian egotism which will recognise nothing greater than itself . . .
>
> Pathos of the gentle kind he does not frequently exhibit. Suffering, it is true, must always be pathetic, and he abounds in suffering; but he gets his pathos chiefly by the road of physical horror – not of moral sweetness conquering misery by patience. And the pathos of his horrors is generally secondary to their sublimity or grimness, or even to their merely pictorial effect. You cannot imagine the

artist shedding tears over the scenes in his *Dante,* or expecting anyone else to do so.[16]

It is easy to criticise Doré, and he was much criticised in his lifetime. Yet we are dazzled still by his breathtaking prodigality. Nearly a century after his death, we laugh at his Russian history, his wickedly humorous comments on Parisian life; we are struck by the savage grandeur of his plates for *The Wandering Jew,* his brutal impression of the Victorian slums, his poignant and engaging illustrations to Perrault. We revel in his vital, out-rageous illustrations to Rabelais, the fantastic, compassionate pictures which he drew for *Don Quixote,* the extraordinary Romantic energy which inspired his *Ancient Mariner* and his *Travailleurs de la mer.* He could be delicate and gentle, crude and boisterous, and frequently sadistic. He could be accurate and fantastic, realistic and unreal. Like John Martin, he could contain an army in a page, and limitless heights and depths in a tiny space. He could conjure up awe and mystery, and terror. He so mastered black and white that he could make them suggest not only colour, but heat and cold. He was immature, he was unschooled, and perhaps his ambitions outran his extraordinary powers. Doré still remains a classic exponent of his art.

Notes

I

1. Millicent Rose, *Gustave Doré* (Pléiades Books, 1946), 13ff; Blanchard W. Jerrold, *Life of Gustave Doré* (W. H. Allen, 1891), 57
2. Blanchard W. Jerrold, *op. cit.*, 10
3. Edmund Ollier, Memoir of Doré in *The Doré Gallery* (Cassell, Petter & Galpin, 1870), xvff
4. Anon., *Nouvelle Description de Strasbourg* (Strasbourg Fietta frères, 1858), 19, 25–6
5. *Ibid.*, 20
6. Jerrold, *op. cit.*, 4
7. *Ibid.*, 5, 6
8. Ollier, *loc. cit.*
9. Jerrold, *op. cit.*, 7, 9

2

1. Edmond About, *Nouvelles et souvenirs* (Hachette, 1896), 326
2. René Delorme, *Gustave Doré. Peintre, sculpteur, dessinateur et graveur* (Librairie d'Art, Ludovic Baschet, 1879), 9, 10
3. L. Lemercier de Neuville, *Gustave Doré* (Librairie Nouvelle, 1861), 16–17
4. Théodore de Banville, *Camées parisiens* (Charpentier, 1883), 237
5. Blanche Roosevelt, *Life and Reminiscences of Gustave Doré* (Sampson Low, 1885), 167
6. Gustave Claudin, *Mes Souvenirs. Les Boulevards de 1840–1870* (Calmann-Lévy, 1884), 25–6
7. Lemercier de Neuville, *op. cit.*, 6, 7
8. Ollier, *op. cit.*, 70
9. To Nadar, 16 May 1859. Charles Baudelaire, *Lettres, 1841–1866* (Mercure de France, 1905), 207–8

3

1. E. H. Yates, *Celebrities at Home*, Reprint from *The World* (Office of *The World*, 1877), I, 133ff
2. Ollier, *loc. cit.*
3. Henry Vizetelly, *Glances back through seventy years*, 2 vols. (Kegan Paul, 1893), I, 388, 389

4. Henri Bouchot, *La Lithographie* (Librairies-Imprimeries réunies, 1895), 192
5. Ollier, *loc. cit.*
6. *La Presse*, 16 May 1854
7. Théophile Gautier, *Les Beaux-Arts en Europe, 1855*, 2e série (Michel Lévy, 1856), II, 24–5
8. Edmond About, *Voyage à travers l'exposition des Beaux-Arts (peinture et sculpture)* (Hachette, 1855), 192–4
9. Blanchard W. Jerrold, *At Home in London and Paris* (W. H. Allen, 1864), 19ff

4

1. Roosevelt, *op. cit.*, 181
2. *Ibid.*, 182–3
3. Jerrold, *Life of Gustave Doré*, 55
4. Ollier, *loc. cit.*
5. *The Legend of the Wandering Jew.* Preface (unnumbered page)
6. *Ibid.* (unnumbered page)
7. *The Athenaeum*, 3 January 1857
8. Edmond About, *Nos Artistes au Salon de 1857* (Hachette, 1858), 343–4
9. Marcel Thiébaut, *Edmond About* (N. R. F. Gallimard, 1936), 93–4
10. J. Prinet, A. Dilasser, *Nadar* (Armand Colin, 1966), 128–9, 139
11. Vizetelly, *op. cit.*, I, 390–1
12. Jerrold, *Life of Gustave Doré*, 99–101
13. Herbert Weinstock, *Rossini* (O.U.P., 1968), 272
14. Victor Fournel, *Figures d'hier et d'aujourd'hui* (Calmann-Lévy, 1883), 137
15. *Ibid.*, 138
16. *Ibid.*
17. Judith Gautier, *Le Collier des jours. Le Second Rang du collier* (Juven, 1909), 185–6
18. Edmond et Jules de Goncourt, *Journal* (Monaco, Imprimerie Nationale, 1956), I, 35
19. Ollier, *loc. cit.*

5

1. Rose, *op. cit.*, 57
2. *La Revue des Deux Mondes*, 15 November 1861, 440

3. Dante, *Inferno*, Introduction, 9
4. Théophile Gautier, *Abécédaire du Salon de 1861* (Dentu, 1861), 130–3
5. Maxime du Camp, *Le Salon de 1861* (Librairie Nouvelle, 1861), 68–9
6. *Ibid.*, 73
7. Claudin, *op. cit.*, 253ff
8. Gustave Claudin, *Méry. Sa vie intime* (Librairie Bachelin-Deflorenne, 1868), 70, 71, 85; *Mes Souvenirs, loc. cit.*
9. Quoted by M. G. Duplessis, *Catalogue* (Cercle de la Librairie, de l'Imprimerie, 1885), 34

6

1. Goncourt, *Journal* (Charpentier ed.), II, 100
2. Georges Mouly, *La Vie prodigieuse de Victorien Sardou (1831–1908)* (Albin Michel, 1931), 153
3. Louisa Lauw, *Fourteen Years with Adelina Patti*, Transl. Clare Brune (Remington, 1884), 85–6
4. Roosevelt, *op. cit.*, 265ff
5. L. Lemercier de Neuville, *Souvenirs d'un montreur de marionnettes* (Bauche, 1911), 196
6. *Ibid.*, 197
7. Roosevelt, *op. cit.*, 289
8. Lauw, *op. cit.*, 93
9. *La Vie parisienne*, 28 March 1868, 222–3
10. Jerrold, *op. cit.*, 307
11. Roosevelt, *op. cit.*, 289–90
12. W. H. Holden, *The Pearl of Plymouth* (British Technical & General Press, 1950), 145–6, note
13. J.-L. Vaudoyer, *Alice Ozy, ou l'Aspasie moderne* (M.-P. Trémois, 1930), *passim*; Roosevelt, *op. cit.*, 290
14. Jerrold, *op. cit.*, 308
15. Roosevelt, *op. cit.*, 292–3
16. *Ibid.*, 290–1
17. Jerrold, *op. cit.*, 308
18. Roosevelt, *op. cit.*, 293
19. *Ibid.*, 291
20. *Ibid.*, 285
21. *Ibid.*, 375
22. *Ibid.*, 354–5

7

1. Jules Claretie, *Peintres et sculpteurs contemporains* (Charpentier, 1873), 25–8
2. Thierry, Preface to *The Epicurean*, xxvii
3. A. R. Waller (ed.), *Gossip from Paris during the Second Empire* (Kegan Paul, 1900), 110
4. Fournel, *op. cit.*, 477
5. Goncourt, *Journal*, VII, 193–4
6. L. de Hegermann-Lindencrone, *In the Courts of Memory 1858–1875* (Harper & Bros., 1912), 116
7. *Ibid.*, 151–2
8. Roosevelt, *op. cit.*, 358–9
9. Claretie, *op. cit.*, 138
10. Lemercier de Neuville, *Gustave Doré*, 18–19, 20

8

1. Victor Hugo, *Correspondance* (Albin Michel, 1950), II (1849–1866), 569–70
2. Felix M. Whitehurst, *Court and Social Life in France under Napoleon III*, 2 vols. (Tinsley Bros., 1873), I, 278
3. Waller, *op. cit.*, 272
4. *The Athenaeum*, 21 December 1867, 844–5
5. Hallam, Lord Tennyson, *Alfred, Lord Tennyson*, 2 vols, (Macmillan, 1897), II, 77

9

1. Jerrold, *op. cit.*, 276
2. Roosevelt, *op. c.it.*, 209–300
3. *Ibid.*, 382
4. Quoted by Ollier, *op. cit.*, xx–xxi
5. *Ibid.*
6. *Ibid.*
7. Weinstock, *op. cit.*, 352–3
8. Waller, *op. cit.*, 305–6
9. *Ibid.*, 312
10. *Ibid.*
11. Saint-Saëns, *Au Courant de la vie*, 27–8
12. Undated. British Library, Additional MS. 33964, fol. 17
13. *La Vie parisienne*, 27 February 1869, 178

14. *The Athenaeum*, 1 May 1869, 612
15. Amelia Edwards archive, Somerville College, Oxford
16. Jerrold, *op. cit.*, 150ff
17. *Ibid.*, 273ff

10

1. Jerrold, *op. cit.*, 57
2. 17 February 1871. Amelia Edwards archive, Somerville College, Oxford
3. Rose, *op. cit.*, 44–5
4. 17 February 1871. Amelia Edwards archive, Somerville College, Oxford
5. Doré, *Versailles et Paris en 1871*. Introductory note, 8 February 1877.
6. Fournel, *loc. cit.*
7. Jerrold, *op. cit.*, 165
8. *Ibid.*
9. *Ibid.*, 291
10. Amelia Edwards archive, Somerville College, Oxford
11. Jerrold, *op. cit.*, 188ff
12. Roosevelt, *op. cit.*, 368
13. *Ibid.*
14. *Ibid.*, 368–9
15. Jerrold, *op. cit.*, 189
16. *Ibid.*, 190
17. Roosevelt, *op. cit.*, 370
18. Reprinted in Théophile Gautier, *Tableaux de siège*, (Charpentier, 1871), 214ff
19. Delorme, *op. cit.*, 42
20. Gautier, *Tableaux de siège*, 216, 217 and *passim*
21. Jerrold, *loc. cit.*

11

1. Claretie, *op. cit.*, 313–4
2. Rose, *op. cit.*, 42; Jerrold, *op. cit.*, 286
3. 12 June 1879. Amelia Edwards archive, Somerville College, Oxford
4. Jerrold, *op. cit.*, 199–200
5. Eric de Maré, *The London Doré Saw* (Allen Lane, The Penguin Press, 1973), 9

6. *The Athenaeum*, 6 January 1872, 23
7. Fournel, *Les Artistes français*, 466
8. Jerrold, *op. cit.*, 204–7
9. *Ibid.*
10. 22 June 1873. Amelia Edwards archive, Somerville College, Oxford
11. Quoted by Jerrold, *op. cit.*, 339
12. 22 June 1873. Amelia Edwards archive, Somerville College, Oxford
13. *Ibid.*
14. Roosevelt, *op. cit.*, 379
15. *Ibid.*, 380–1
16. *Ibid.*, 381–2
17. Jerrold, *Life of Gustave Doré*, 294
18. *Ibid.*

12

1. Duplessis, *op. cit.*, 118–19
2. *The Athenaeum*, 3 December 1873, 775
3. Roosevelt, *op. cit.*, 412
4. Jules Claretie, *L'Art et les artistes français contemporains* (Charpentier, 1876), 264–5
5. Amelia Edwards archive, Somerville College, Oxford
6. Zola, *Salons* (Genève, Droz, 1959), 154
7. Claretie, *op. cit.*, 298–9
8. Arnold Mortier, *Les Soirées parisiennes de 1876* (Dentu, 1877), 42
9. Roosevelt, *op. cit.*, 311, 312
10. Edward Gordon Craig, *Henry Irving* (Dent, 1930), 127, 128, 129
11. For comments on Doré's hotels, and the London of his time, see *The Golden Guide to London, passim*
12. E. H. Yates, *Celebrities at Home* Reprinted from *The World* (Office of *The World*, 1877), I, 134, 135
13. Roosevelt, *op. cit.*, 428
14. 4 Janaury 1872. Rev. Francis Kilvert, *Diary* (Cape, 1939), II, 109
15. Rev. E. P. Hood, *Catholic Sermons*, Vol. I (Longley, 1874). III
16. Delorme, *op. cit.*, 37
17. E. F. Benson, *As we were. A Victorian Peep-show* (Longmans, Green, 1930), 253–4
18. *The Athenaeum*, 19 February 1876, 271–2
19. *Ibid.*
20. Henry James, *Parisian Sketches* (Hart-Davis, 1958), 137–8

21. Zola, *op. cit.*, 178, 179
22. 17 February 1876. Amelia Edwards archive, Somerville College, Oxford
23. Roosevelt, *op. cit.*, 429–30
24. Letter from the Librarian, Warwick Castle, to the author, 2 June 1978
25. 4 October 1876. Amelia Edwards archive, Somerville College, Oxford

13

1. February 1877. Amelia Edwards archive, Somerville College, Oxford
2. Jerrold, *op. cit.*, 349
3. Delorme, *op. cit.*, 58
4. *The Athenaeum*, 12 May 1877, 612
5. Yates, *op. cit.*, 131ff
6. Arnold Mortier, *Les Soirées parisiennes de 1877* (Dentu, 1878), 209; *Les Soirées parisiennes de 1880* (Dentu, 1881)
7. André Maurois, *Les Trois Dumas* (Hachette, 1957), 423–4
8. Comte de Maugny, *Cinquante ans de souvenirs 1859–1909* (Plon-Nourrit, 1914), 182ff
9. Yates, *op. cit.*, 139
10. Sarah Bernhardt, *Ma Double Vie. Mémoires* (Charpentier & Fasquelle, 1907), 369
11. Vizetelly, *op. cit.*, 391
12. Delorme, *op. cit.*, 65–6
13. Anon., *Nice, Monaco* (Guides Joanne, Hachette, 1896), 64
14. Delorme, *op. cit.*, 54, 59
15. Roosevelt, *op. cit.*, 417
16. *Ibid.*, 442–3
17. *The Athenaeum*, 31 May 1879, 704
18. 12 June 1879. Amelia Edwards archive, Somerville College, Oxford
19. Roosevelt, *op. cit.*, 442
20. *La Nouvelle Revue*, April 1883, 623ff
21. Bernhardt, *op. cit.*, 416

14

1. Goncourt, *Journal*, XII, 63
2. Rose, *op. cit.*, 50–1

3. Zola, *op. cit.*, 14
4. *Ibid.*, 253
5. Roosevelt, *op. cit.*, 445
6. Jerrold, *op. cit.*, 274–5
7. *Ibid.*, 275
8. Roosevelt, *op. cit.*, 444
9. Amelia Edwards archive, Somerville College, Oxford
10. Fournel, *op. cit.*, 481–2
11. Alexandre Dumas *fils*, Preface to G. Doré's *Le Monument de Alexandre Dumas* (Librairie des Bibliophiles, 1880), 1–2
12. Jules Claretie, *La Vie à Paris, 1883* (Havard, n.d.), 43–4
13. Roosevelt, *op. cit.*, 449–50
14. Goncourt, *Journal*, XII, 162
15. Jerrold, *op. cit.*, 346
16. *Ibid.*, 359, 368
17. Roosevelt, *op. cit.*, 451
18. Jerrold, *op. cit.*, 270, 369
19. *Ibid.*, 225

15

1. Fournel, *op. cit.*, 438
2. *La Revue politique et littéraire*, 27 January 1883, 124
3. Dumas *fils*, *op. cit.*, 82ff
4. Edgar Allan Poe, *The Raven* (Sampson Low, 1883). Comment by Doré, 14
5. *La Nouvelle Revue*, April 1883, 623ff
6. *Athenæum*, 3 February 1883, 161
7. *La Vie à Paris*, 1883, 44
8. Jerrold, *op. cit.*, 224
9. About, *Nouvelles et Souvenirs*, 319
10. *Dumas fils, op. cit.*, 86
11. Beraldi, *loc. cit.*
12. Rose, *op. cit.*, 65
13. Vandoyer, *op. cit.*, 111
14. Dubufe, *op. cit.*, 625
15. Edgar Allan Poe, *loc. cit.*
16. Ollier, *loc. cit.*

Select Bibliography

English books have been published in London, French books in Paris, unless otherwise stated.

ABOUT, E. *Voyage à travers l'exposition des Beaux-Arts (peinture et sculpture)* (Hachette, 1855)

Nos Artistes au Salon de 1857 (Hachette, 1858)

Nouvelles et souvenirs (Hachette, 1896)

ANON. *Nouvelle Description de Strasbourg* (Strasbourg Fietta fréres, 1858)

The Golden Guide to London (Sampson Low, 1875)

Nice, Monaco (Guides Joanne, Hachette, 1896)

BANVILLE, T. de *La Lanterne magique. Camées parisiens. La Comédie-Française* (Charpentier, 1883)

BAUDELAIRE, C. *Lettres, 1814–1866* (Mercure de France, 1906)

BENSON, E. F. *As we were. A Victorian peep-show* (Longmans Green, 1930)

BERALDI, H. *Les Graveurs du XIXe siècle*, vol. VI (Conquet, 1887)

BERNHARDT, S. *Ma Double Vie. Mémoires* (Charpentier & Fasquelle, 1907)

BOUCHOT, H. *La Lithographie* (Librairies-Imprimeries réunies, 1895)

CLARETIE, J. *Peintres et Sculpteurs contemporains* (Charpentier, 1873)

L'Art et les artistes français contemporains (Charpentier, 1876)

La Vie à Paris, 1880 (Havard, n.d.)

La Vie à Paris, 1881 (Havard, n.d.)

La Vie à Paris, 1882 (Havard, n.d.)

La Vie à Paris, 1883 (Havard, n.d.)

La Vie à Paris, 1885 (Havard, n.d.)

CLAUDIN, G. *Méry. Sa vie intime* (Librairie Bachelin-Deflorenne, 1868)

Mes Souvenirs. Les Boulevards de 1840–1870 (Calmann-Lévy, 1884)

CRAIG, E. G. *Henry Irving* (Dent, 1930)

DELORME, R. *Gustave Doré. Peintre, sculpteur, dessinateur et graveur* (Librairie d'Art, Ludovic Baschet, 1879)

DÉZÉZ, L. *Gustave Doré*, Bibliographie et catalogue complète de l'oeuvre (Editions Marcel Seheur, 1930)

DUBUFE, G., *fils. Gustave Doré.* (*La Nouvelle Revue*, April 1883)

DU CAMP, M. *Le Salon de 1861.* (Librairie Nouvelle, 1861)

DUMAS, A., *fils. Le Monument de Alexandre Dumas*. Oeuvre de Gustave Doré. Avec une préface par M. Alexandre Dumas *fils* (Librairie des Bibliophiles, 1884)

DUPLESSIS, M. G. *Catalogue des dessins, aquarelles et estampes de Gustave Doré exposés dans les salons du Cercle de la Librairie (mars 1885) avec une notice biographique par M. G. Duplessis* (Cercle de la Librairie, de l'Imprimerie, 1885)

FOURNEL, V. *Figures d'hier et d'aujourd'hui* (Calmann-Lévy, 1883)
 Les Artistes français contemporains (Mame, 1885)

GAUTIER, J. *Le Collier des jours. Le Second Rang du collier* (Juven, 1909)

GAUTIER, T. *Les Beaux-Arts en Europe, 1855*, 2e série (Michel Lévy, 1856)
 Abécédaire du Salon de 1861 (Dentu, 1861)
 Tableaux de siége. Paris, 1870–1871 (Charpentier, 1871)

GONCOURT, E. & J. de *Journal*. Mémoires de la vie littéraire. Texte intégral établi et annoté par Robert Ricatte (Monaco, Imprimerie Nationale, 1956)

GOSLING, N. *Gustave Doré* (Newton Abbot, David & Charles, 1973)

HEGERMANN-LINDENCRONE, L. de *In the Courts of Memory, 1858–1875*. From contemporary letters (Harper & Bros., 1912)

HOLDEN, W. H. *The Pearl from Plymouth*. Eliza Emma Crouch alias Cora Pearl (British Technical & General Press, 1950)

HOOD, Rev. E. P. (*et al.*) *Catholic Sermons*, vol. I (Longley, 1874)

HUGO, V. *Correspondance*, vol. II (1849–1866) (Albin Michel, 1950)

JAMES, H. *Parisian Sketches*. Letters to the *New York Tribune*, 1875–1876. Edited with an Introduction by Leon Edel and Ilse Dusoir Lind (Hart-Davis, 1958)

JERROLD, B. W. *At Home in London and Paris* (W. H. Allen, 1864)
 Life of Gustave Doré (W. H. Allen, 1891)

JOANNE, A. *Bade et la Forêt-Noire* (Hachette, 1863)

KILVERT, Rev. F. *Selections from the Diary of the Rev. Francis Kilvert, 23 August 1871–13 May 1874*. Chosen, edited and introduced by William Plomer (Cape, 1939)

LAUW, L. *Fourteen Years with Adelina Patti*. Translated by Clare Brune (Remington, 1884)

LEBLANC, H. *Catalogue de l'oeuvre complète de Gustave Doré* (Ch. Bosse, 1931)
 Bibliothèque de Monsieur et Madame Henri Leblanc. Catalogue. (Ch. Bosse, 1932)

LEMERCIER DE NEUVILLE, L. *Gustave Doré* (Librairie Nouvelle, 1861)
 Souvenirs d'un montreur de marionnettes (Bauche, 1911)

MARÉ, E. de *The London Doré saw*. A Victorian Evocation (Allen Lane, The Penguin Press, 1973)

MAUGNY, Comte de *Cinquante ans de souvenirs, 1859–1909* (Plon-Nourrit, 1914)

MONTEGUT, E. *Une Interprétation pittoresque de Dante. L'Enfer, avec les dessins de M. Doré* (*Revue des Deux Mondes*, 15 November 1861)

MORTIER, A. *Les Soirées parisiennes de 1876*. Par un monsieur de l'orchestre (Dentu, 1877)

 Les Soirées parisiennes de 1877. Par un monsieur de l'orchestre (Dentu, 1878)

 Les Soirées parisiennes de 1880. Par un monsieur de l'orchestre (Dentu, 1881)

 Les Soirées parisiennes de 1881. Par un monsieur de l'orchestre (Dentu, 1882)

MOULY, G. *La Vie prodigieuse de Victorien Sardou (1831–1908)* (Albin Michel, 1931)

NADAR *Nadar Jury au Salon de 1857* (Librairie Nouvelle, 1857)

NOWELL-SMITH, S. *The House of Cassell* (Cassell, 1958)

OLLIER, E. *The Doré Gallery*. Containing 250 beautiful engravings . . . With Memoir of Doré, critical essay, and descriptive letterpress, by Edmund Ollier (Cassell, Petter, & Galpin, 1870)

PARMÉNIE, A., BONNIER DE LA CHAPELLE, C. *Histoire d'un éditeur et de ses auteurs*. P.-J. Jetzel (Stahl) (Albin Michel, 1953).

PRINET, J., DILASSER, A. *Nadar* (Armand Colin, 1966)

RICHARDSON, J. *Théophile Gautier. His Life and Times* (Reinhardt, 1958)

ROOSEVELT, B. *Life and Reminiscences of Gustave Doré* (Sampson Low, 1885)

ROSE, M. *Gustave Doré* (Pleiades Books, 1946)

SAINT-SAËNS, C. *Au courant de la vie* (Dorbon aîné, 1914)

TAINE, H. *H. Taine. Sa vie et sa correspondance*, 4 vols. (Hachette, 1902–1907)

TENNYSON, Hallam, Lord. *Alfred, Lord Tennyson*. A memoir by his son, 2 vols. (Macmillan, 1897)

THIÉBAUT, M. *Edmond About* (N. R. F. Gallimard, 1936)

TROMP, E. *Gustave Doré* (Rieder, 1932)

VAUDOYER, J.-L. *Alice Ozy, ou l'Aspasie moderne* (M.-P. Trémois, 1930)

VIZETELLY, E. A. *My Days of Adventure*. The Fall of France, 1870–1871 (Chatto & Windus, 1914)

VIZETELLY, H. *Glances Back Through Seventy Years*. 2 vols. (Kegan Paul, 1893)

WALLER, A. R. (ed.) *Gossip from Paris during the Second Empire.* Correspondence (1864–1869) of Anthony B. North Peat. Attaché au Cabinet du Ministre de l'Intérieur and, later, Attaché au Conseil d'État (Kegan Paul, 1903)

WEINSTOCK, H. *Rossini.* A Biography (O.U.P., 1968)

WHITEHURST, F. M. *Court and Social Life in France under Napoleon III,* 2 vols. (Tinsley Bros., 1873)

YATES, E. H. *Celebrities at Home,* reprinted from *The World* (Office of *The World,* 1877)

ZOLA, É. *Salons.* Recueillis, annotés et présentés par F.W.J. Hemmings et Robert J. Niess, et précédés d'une étude sur *Émile Zola critique d'Art* de F.W.J. Hemmings (Genève, Droz, 1959)

Select list of works illustrated by Gustave Doré

ABOUT, E. *Le Roi des Montagnes.* 5e édition. Illustrée par Gustave Doré (Hachette, 1861)

ANON. *Fairy Tales Told Again.* Illustrated by Gustave Doré (Cassell, Petter & Galpin, 1872)

ANON. *Histoire pittoresque, dramatique et caricaturale de la Sainte Russie.* Commentée et illustrée de 500 magnifiques gravures par Gustave Doré (J. Bry aîné, 1854)

Spanish Pictures. Drawn with pen and pencil. With illustrations by Gustave Doré, and other eminent Artists (The Religious Tract Society, 1870)

Daily Devotion for the Household (Cassell, Petter & Galpin, 1873)

The King's Page. An Historical Romance. With illustrations by Gustave Doré (Maxwell, 1880)

The Man among the Monkeys; or, Ninety Days in Apeland. With illustrations, many of them by Gustave Doré (Ward, Lock, 1873)

ARIOSTO Roland Furieux. Poème Héroïque. Traduit par A.-J. du Pays et illustré par Gustave Doré (Hachette, 1879)

BALZAC, Honoré de *Les Contes drôlatiques.* Illustrés de dessins de Gustave Doré (Garnier frères, 1861)

BLACKBURN, H. *The Pyrenees.* With upwards of a hundred illustrations by Gustave Doré (Sampson Low, Son & Marston, 1867)

BRADDON, M. E. *Aladdin; or, the Wonderful Lamp. Sindbad, the*

sailor; or, the Old Man of the Sea. Ali Baba; or, the Forty Thieves.
Revised by M. E. Braddon. Illustrated by Gustave Doré and other
artists (Maxwell, 1886)

CHATEAUBRIAND, le Vicomte de *Atala*. Avec les dessins de Gustave
Doré (Hachette, 1863)

CRAIK, G. M. *Twelve Old Friends*. A Book for Boys and Girls, With
Eight Plates by Gustave Doré (W. Swan Sonnenschein, 1885)

DANTE, A. *The Vision of Purgatory and Paradise*. Translated by the
Rev. Henry Francis Cary, M.A., and illustrated with the designs of
M. Gustave Doré. With critical and explanatory notes (Cassell,
Petter & Galpin, 1866)

DAVILLIER, le Baron Charles *L'Espagne*. Illustrée de 309 gravures
desinées sur bois par Gustave Doré (Hachette, 1874)

(DIPLOMATE, Un) *Histoire complète de la guerre d'Italie*. Illustra-
tions de Gustave Doré (Lécrivain et Toubon, 1859)

DORÉ, G. *A Dozen Specimens of Gustave Doré from his 'Inferno' of
Dante, 'Fairy Tales' of Perrault, and 'Captain Castagnette' of
Manuel* (Beeton, 1866)

Two Hundred Sketches, Humorous and Grotesque (Warne, 1867)

The Doré Gift Book of Illustrations to Tennyson's 'Idylls of the King'.
With introductory notice of the Arthurian legends (Moxon, 1878)

Versailles et Paris en 1871. D'après les dessins originaux de Gustave
Doré. Préface de M. Gabriel Hanotaux (Plon-Nourrit, 1907)

Ménagerie Parisienne (Basel, Amerbach-Verlag, 1947)

EDGAR, J. G. *Cressy and Poictiers: or, the Story of the Black Prince's
Page*. Illustrated with numerous engravings principally from
designs by Robert Dudley and Gustave Doré (Beeton, 1865)

ÉNAULT, L. *Londres*. Illustré de 174 gravures sur bois par Gustave
Doré (Hachette, 1876)

GASTINEAU, B. *La France en Afrique, et l'Orient à Paris*. Illustré par
Gustave Doré (Gustave Barba, 1856)

Chasses au lion et à la panthère en Afrique. Illustrées de dix-sept
dessins sur bois, par Gustave Doré. (Hachette, 1863)

De Paris en Afrique. Voyage et chasses en Algérie. Illustrés de neuf
dessins sur bois de Gustave Doré et Janet-Lange (Dentu, 1865)

GÉRARD, J. *La Chasse au lion*. Ornée de gravures dessinées par
Gustave Doré (Librairie Nouvelle, 1855)

GIGAULT DE LA BÉDOLLIÈRE, E. *Le Nouveau Paris*. Histoire de
ses 20 arrondissements. Illustrations de Gustave Doré (Barba,
1866)

Histoire des environs du Nouveau Paris. Illustrée par Gustave Doré
(Barba, 1860)

Histoire de la Guerre de Mexique, de 1861 à 1866. Illustrée par Gustave Doré et Janet-Lange (Barba, 1866)

La France et la Prusse. Le Traité de Londres. Illustrations de Gustave Doré (Barba, 1867)

GODARD, l'Abbé L. *L'Espagne.* Moeurs et Paysages. Histoire et Monuments. Orné de quatre gravures d'après M. Gustave Doré (Tours, Mame, 1862)

HANSON, C. H. *Stories of the Days of King Arthur.* With illustrations by Gustave Doré (Nelson, 1882)

HOOD, T. *Poetical Works.* Edited, with a critical memoir, William Michael Rossetti. Illustrated by Gustave Doré (Moxon, 1871)

HUGO, V. *Toilers of the Sea.* Authorized English translation, by A. Moy Thomas. Two illustrations by Gustave Doré. (Sampson Low, Son & Marston, 1867)

JAUFRE, C. *Geoffrey the Knight.* A Tale of Chivalry of the Days of King Arthur. With twenty whole-page engravings by Gustave Doré (Nelson, 1869)

JERROLD, B. *The Cockaynes in Paris. Or, 'Gone Abroad'.* With sketches by Gustave Doré, and other illustrations of the English abroad from a French point of view (John Camden Hotten, 1871)

KNATCHBULL-HUGESSEN, E. H. *River Legends. Or, Father Thames and Father Rhine* (Daldy, Isbister & Co., 1875)

LAFON, M. (Tr.) *Fierabas.* Légende nationale. Illustrée de douze belles gravures dessinées par G. Doré (Librairie nouvelle, 1857)

LA FONTAINE, J. de *Fables.* Avec les dessins de Gustave Doré, 2 vols. (Hachette, 1867)

LAUJON, L. de *Contes et Légendes.* Ouvrage illustré de 275 vignettes par Doré, Bertall, Foulquier, Castelli, Morin (Hachette, 1862)

MALO, C. *Les Chasseurs d'autrefois.* Vieux chants populaires de nos pères. Recueillis et annotés par Charles Malo. Illustrations par Gustave Doré (Laisne, 1861)

MALTE-BRUN *Géographie du Théâtre de la Guerre et des états circon-voisins.* Italie, Autriche, Prusse, Confédération Germanique, Suisse, Hollande et Belgique (Barba, 1859)

Les États-Unis et le Mexique. Histoire et Géographie. Illustrations de Gustave Doré (Barba, 1862)

MARX, A. *Histoires d'une minute.* Physionomies parisiennes. Illustrées par Gustave Doré. Avec une préface de Charles Monselet (Dentu, 1864)

MENDÈS, C. *Hespérus.* Poème Swedenborgien (1869). (Librairie des Bibliophiles, 1872)

MICHAUD *Histoire des Croisades.* Illustrée de 100 grandes compositions par Gustave Doré. 2 vols. (Furne, Jouvet, 1877)

MILTON, J. *Paradise Lost*. Illustrated by Gustave Doré. Edited with notes and a life of Milton, by Robert Vaughan, D.D. (Cassell, Petter & Galpin, 1866)

MOORE, T. *L'Épicurien*. Traduit par Henri Butat. Préface d'Édouard Thierry. Dessins de Gustave Doré (Dentu, 1865)

MORAR, the Knight of. *Coila's Whispers*. With illustrations by George Cruikshank and Gustave Doré (Blackwood, 1869)

OLLIER, E. *A Popular History of Sacred Art* (Cassell, Petter, Galpin & Co, 1882)

PARDON, G. *Boldheart the Warrior, and his Adventures in the haunted Wood*. A tale of the times of good King Arthur. Illustrated by Gustave Doré (Blackwood, 1859)

PEACOCK, W. F. *The Adventures of St George after his famous encounter with the dragon* (Blackwood, 1858)

PERRAULT, C. *Contes*. Dessins par Gustave Doré. Préface par P.-J. Stahl (Hetzel, 1862)

POE, E. A. *The Raven*. Illustrated by Gustave Doré. With a comment upon the poem by Edmund Clarence Stedman (Sampson Low, 1883)

RABELAIS, F. *Oeuvres*. Illustrations par Gustave Doré (J. Bry aîné, 1854)

SAINTINE, X.-B. *La Mythologie du Rhin*. Illustrée par Gustave Doré (Hachette, 1862)

SHAKESPEARE, W. *The Tempest*. Illustrated by Birket Foster, Gustave Doré (*et al.*) (Bell & Daldy, 1860)

TAINE, H. *Voyage aux Eaux des Pyrénées*. Illustré de 65 vignettes sur bois par Gustave Doré (Hachette, 1855)

TENNYSON, A. *Idylls of the King*. Illustrated by Gustave Doré (Moxon, 1868)

THORNBURY, G. W, (tr.) *The Legend of the Wandering Jew*. Illustrated by Gustave Doré (Addey, 1857)

Index